THE MAN WHO
PAINTED
THE UNIVERSE

THE MAN WHO PAINTED THE UNIVERSE

THE STORY OF A
PLANETARIUM

IN THE HEART OF THE
NORTH WOODS

RON LEGRO & AVI LANK

ELISHA D. SMITH PUBLIC LIBRARY
MENASHA, WISCONSIN

WISCONSIN HISTORICAL SOCIETY PRESS

Published by the Wisconsin Historical Society Press
Publishers since 1855
© 2015 by Ron Legro and Avrum Lank

For permission to reuse material from *The Man Who Painted the Universe*
(978-0-87020-711-2; e-book ISBN: 978-0-87020-712-9), please access
www.copyright.com or contact the Copyright Clearance Center, Inc. (CCC),
222 Rosewood Drive, Danvers, MA 01923, 978-750-8400. CCC is a not-for-
profit organization that provides licenses and registration for a variety of users.

wisconsinhistory.org

All photographs are from the collection of Frank A. Kovac Jr. unless
otherwise credited.
Photographs identified with WHi or WHS are from the Society's collections;
address requests to reproduce these photos to the Visual Materials Archivist
at the Wisconsin Historical Society, 816 State Street, Madison, WI 53706.

Front cover: Shutterstock; back cover: photograph by Dean Acheson

Printed in Wisconsin, USA
Cover design by Anders Hanson, Mighty Media
Interior design and typesetting by Integrated Composition Systems,
Spokane, Washington

19 18 17 16 15 1 2 3 4 5

Library of Congress Cataloging-in-Publication Data

Legro, Ron.
 The man who painted the universe : the story of a planetarium in the
heart of the north woods / Ron Legro & Avi Lank.
 pages cm
 Summary: The story of Frank Kovac, who built a planetarium in the
woods of Wisconsin
 Includes bibliographical references.
 ISBN 978-0-87020-711-2 (hardcover : alk. paper) — ISBN 978-0-87020-712-9
(e-book) 1. Kovac, Frank, 1965- 2. Astronomers—Wisconsin—
Biography. 3. Astronomy. 4. Planetariums. I. Lank, Avi.
II. Title. III. Title: Planetarium in the north woods.
 QB36.K685L44 2015
 520.92—dc23
 [B] 2014039426

∞ The paper used in this publication meets the minimum requirements
of the American National Standard for Information Sciences—Permanence
of Paper for Printed Library Materials, ANSI z39.48-1992.

To Michele and Dannette

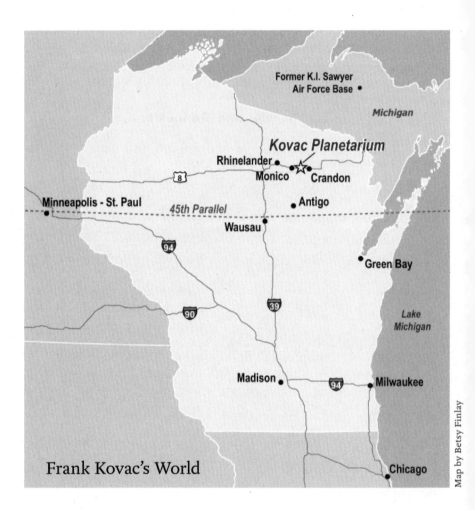

Former K.I. Sawyer
Air Force Base •

Michigan

Kovac Planetarium

Rhinelander •
Monico • ☆ Crandon
Antigo •

Minneapolis - St. Paul •
45th Parallel
Wausau •

Green Bay •

Lake Michigan

Madison •
Milwaukee •

Frank Kovac's World

Chicago •

Map by Betsy Finlay

CONTENTS

Prologue

DREAM DESCENDING

> I dream things that never were;
> and I say "Why not?"
> —George Bernard Shaw, *Back to Methuselah*

On a near-freezing March evening in 2001, Frank A. Kovac Jr.'s dream came crashing down around him, all 3,500 pounds of it. The dream was a hollow wooden globe twenty-two feet in diameter, and it had just become a deadly object.

Working mostly alone inside his makeshift construction shed in tiny Monico, Wisconsin, Frank had spent four years of hard work fashioning this globe. He was pursuing an ultimate goal: building a working planetarium in the unlikely environs of Wisconsin's secluded North Woods.

With great care that night, he had winched the globe off the floor and onto what was supposed to be its permanent home, a thick wooden base ring, inclined and rigged with wheels, which would let him rotate his planetarium—a unique structure, as far as he knew. Frank was inspecting his handiwork close to the ring when, with a creaking noise, the globe began to sway. "Uh-oh, here it goes," Frank recalls thinking. And then, ruefully, "Well, that was a mistake."

Reacting quickly, he ran to the center of the floor underneath the globe, as far away from its inner surface as he could get. Frank crouched as the globe slid off the angled ring and hit the floor. Years later, he remembers how it sounded: "There

was a lot of noise at this point, recalling the movie *Titanic*—sounds of wood splitting as the ship broke apart."

The fall took only seconds but seemed to last much longer. Frank huddled inside and beneath the hollow globe as it came down. As it fell, the globe knocked aside and broke Frank's tall ladder, which barely missed him as it whizzed past. Frank had planned to erect steel support beams later on, but on this fateful evening the floor-based ring sat only on two-by-four timbers. The wood was no match for the globe's nearly two tons of falling mass. The globe sliced through the ring, cutting in half its two-inch-thick plywood like scissors through paper. Large splinters shot past Frank's arm.

It could have been worse. The globe stopped just short of a complete crash—providentially, to Frank's mind. One temporary support strap remained attached, forcing the globe to come to rest at a slight angle against a concrete perimeter wall and keeping its bottom angled about three feet off the floor.

Frank's situation was reminiscent of Buster Keaton's in a scene from the classic 1928 silent movie *Steamboat Bill, Jr.* In it, the famous comedian plays a character who rescues people during a cyclone. The front wall of a house collapses in the storm and looks as if it's going to crush poor Keaton, but the fortunate fellow happens to be standing right in the path of an open window that frames him as the surrounding wall slams to the ground. That was how Frank Kovac survived this crash. The hollow globe with its open bottom fell over him, not on him.

That was lucky. Luckier still, Frank avoided being crushed when the sphere's upper sections stayed intact. He hadn't been touched. To Frank, it wasn't just luck; it was divine intervention, one of a number of such events that would bless his project.

When his perception of time returned to normal and he had gathered his wits, he crawled to safety from under the dome. He had not yet affixed panels to the globe's latticework to enclose it entirely, as he'd planned; thus he was able to squeeze through the gaps.

He surveyed the wreckage. The globe had suffered only minor damage, thanks mainly to the support strap that had broken its fall. But the heavy wooden base ring was split in two, which gave Frank pause. Damage to the globe's base and its support structure was considerable. This was bad, very bad.

He had been so close. Recent months had brought considerable progress, moving idea toward reality. The project was coming together, despite fits and starts, including the crash of an earlier globe in 1997. This day, beyond all the preceding days in his thirty-six years, had started out as one of his best. After more than four years of hard work on a mostly solo effort that had consumed all his free time, Frank had felt his burden lifting, felt his heart once again soaring into the heavens he had long studied with the devotion of a priest and the eyes of a scientist. He had come so far on his improbable quest and his life's dream. Earlier tonight, the dream had seemed within his grasp. Now it lay splayed across the floor.

The crash put his entire dream in doubt. He wasn't sure whether he could complete his project. Should he keep trying? How would he ever fix this? How could he make a rotating globe sturdy and safe enough to invite friends and strangers to sit inside? And what other unforeseen challenges—technical, regulatory, financial—might await him?

The biggest challenge would be teaching himself how to paint the universe inside the completed globe. He had an inkling of the project's magnitude. After all, he'd been painting stars ever since he was a teenager.

BILLIONS AND BILLIONS

I am large, I contain multitudes.
—Walt Whitman, *Song of Myself*

The man who painted the universe began with his bedroom ceiling. It was 1980 and Frank Anthony Kovac Jr. was fifteen years old. The Chicago teenager was passionate about astronomy, spending many nights outdoors inspecting the heavens. As he grew, so did his desire to be with the stars—maybe even among them.

Frank dreamed of becoming an astronaut. Unfortunately, he was at best an average student. Some of his teachers, even into high school, told his parents he was a bit of a slow learner. His math skills in particular were weak.

Frank was wise enough to agree, especially after taking a course at the city's Adler Planetarium and attempting to tackle a serious astronomy text. The Adler is one of the world's foremost planetariums, its staff sprinkled with professional astronomers. Frank fell in love with the place, but the equations he encountered in class left him paralyzed. He quit the course after three months, telling his mother that from that point on he just wanted to stay home and look through his telescope. As for school, he wondered if he would even graduate. He told his mom, "I guess I'll just have to do my best."

His best turned out to be pretty good. Frank's dreams became a plan, and, eventually, the plan became his life's ambi-

tion. A quarter century after his childhood decision to focus on the stars, Frank designed and built his own planetarium, improbably running it as a successful one-man business in the rural woods of northern Wisconsin.

Frank achieved his grown-up success through sheer willpower, insight, invention, and persistence. But before he could build up to escape velocity on his lifelong course to the stars, Frank had to overcome the inertia of childhood insecurity.

His mom regarded her little boy as a bit shy. Despite Frank's academic struggles, he was a bookworm. He had friends and played with neighborhood kids, but his parents noticed he was not particularly gregarious. That began to change the day his mother took her five-year-old to his first show at the Adler. Frank remembers being impressed by the statues of the early astronomers Copernicus and Tycho outside the domed building. Inside, he loved the large display of the solar system, which gave visitors an idea of its scale. But, he recalls, "The highlight of my visits to the Adler were the wonderful sky shows, which eventually led me to where I am today."

The Adler's star projector showed Frank a view of the night sky he could not possibly experience by looking at the real thing. As in many large cities, massive light pollution gave a permanent pinkish glow to Chicago nights, blotting out all but a handful of the brightest stars. The planetarium's simulation had no such limitation. The young boy saw thousands of virtual stars twinkling from the Adler's massive dome. The sight of those revealed wonders thrilled him.

After that, whenever the conversation or a grade school lesson turned to astronomy and space, young Frank became animated and talkative. His parents, brothers and sister, and classmates knew they could rev him up by talking astronomy. Before long, no one, with the possible exception of his teachers, exhibited more knowledge about the stars and planets. By the time he was in high school, one science teacher told Frank, "You're the only one of my students listening when I teach astronomy."

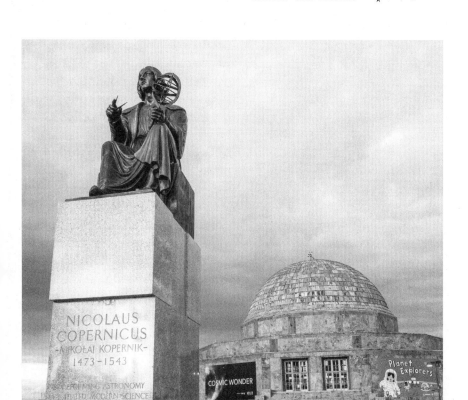

Chicago's Adler Planetarium was an important influence on Frank Kovac during his childhood.

Frank's parents encouraged his unexpected focus. The family visited the Adler and the city's other science museums frequently, but the planetarium remained Frank's favorite. It helped that Frank's dad had dabbled in astronomy. One day when Frank was fourteen, his dad came home with an exciting gadget. Frank Senior loved nosing around in Chicago's many pawn shops. On one expedition, he came across a small telescope, a sixty-millimeter reflector model. He presented it to Frank, and the two of them began stargazing together.

Frank A. Kovac Jr., age 7.

Often father and son would take the telescope out to the Lake Michigan shore or an empty lot near their modest apartment in the Lincoln Park neighborhood. The very first time they used the telescope was on a spring night. The scope was just a small gray tube, not particularly powerful, but the sights Frank saw through it stirred his imagination. The bright, silvery crescent moon offered dramatic vistas. They surveyed its surface, a quarter million miles away, examining its craters and dry seas. Frank's dad explained that crashing meteors and asteroids had created the craters. That knowledge spurred Frank on. He begged his dad to get an even bigger telescope. "When you get out of school, we'll buy a new one," his dad said.

Next they spotted Venus, Earth's nearest planetary neighbor. The image wasn't focused quite right at first. Frank turned the lens adjustment knob, suddenly resolving the planet's white disc. "Wow," said Frank, "that's really neat! Can we look at the stars, too?" His dad told him there weren't many stars to see over the brightly lit city sky, even through a telescope. "To do that, we'll have to go camping."

Lake Geneva, Wisconsin, about seventy-five miles northwest of the city, was among their earliest astronomical expeditions. Urban light pollution not only from Chicago but also from Milwaukee to the northeast spills into that resort area, enough to all but ruin, both then and now, most professional research at the Yerkes Observatory in nearby Williams Bay.

Nevertheless, the Lake Geneva skies were considerably darker than the skies over the Kovac home. Frank's dad picked a remote campsite with few trees. Frank lay on the ground and

As a teenager, Frank Kovac spent many hours with
a telescope. Here, he used it on the shore of Lake
Michigan near his Chicago home in 1979.

gazed up into space. Even without the benefit of a magnifying
lens, he saw, for the first time, hundreds and perhaps even
thousands of stars. But the sky began to cloud over, denying
him the promised treasure. Frank's dad made up for that disap-
pointment by taking his son on a tour of the Yerkes, a dramatic
domed structure on a nearby hilltop. Built in 1897 by the Uni-
versity of Chicago, the observatory, with its thirty-six-inch tele-
scope, the largest refractor ever mounted, tugged at Frank,
boosting his desire to study the stars.

Other trips were more bountiful. When Frank was ten, the
family began to make the two-hundred-mile trip northwest to
the resort area of Wisconsin Dells. This offered Frank his first
truly clear view of the night sky. Later, family friends in Chi-

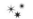

WHi Image ID 35470

A bird's eye view of the University of Chicago's Yerkes Observatory, in Williams Bay, Wisconsin, about 1950.

cago invited the Kovacs to their getaway cottage in Eagle River, Wisconsin, nearly three hundred miles due north. There, just about halfway between the equator and the North Pole and many miles from any large city, Frank witnessed for the first time the shimmering curtains of the aurora borealis—the northern lights that dance in the night sky when the sun sends heavily charged particles into Earth's upper atmosphere. The experience affected him deeply. "I was about fifteen years old," he recalls. "I had originally seen pictures in books of the aurora, yet to see them live was unbelievable. I felt connected with the universe and longed to one day live in the North Woods." On those trips he also got his clearest look yet at the sky-spanning glory of the Milky Way, the galaxy that is home to our own sun and solar system. In Wisconsin's rural regions, individual stars were visible not by the dozens, as they were in the city, but by

the thousands. Frank told his parents he could not wait until he was grown up and able to live somewhere up in northern Wisconsin, where the air was clear, the sky was dark, and the stars were plentiful and bright.

Frank quickly learned star names, planet facts, and the shapes of constellations. He never tired of visiting the planetarium, and he always wanted to know more about the heavens. He was a human black hole, soaking up every bit of cosmological knowledge that came near.

He also began devouring library books on the subject, until he ran through the neighborhood branch's entire collection. Luckily, a classmate introduced him to a used bookstore in their Lincoln Park neighborhood. Frank immediately found an astronomy book he hadn't seen in the library. He pored over the pages right there in the store. Then he found copies of a new magazine, *Astronomy*, published in nearby Milwaukee. The magazine carried star maps. Frank, by now in his early teens, was fascinated with the cartography of the Milky Way.

He'd show star maps to his brothers. They seemed happy for him, but for some reason Frank couldn't fathom, they didn't get excited as he did. He learned so much about the scale of the universe that he quickly outran his father's knowledge of astronomy. "Dad, did you know the Earth races around the sun at 67,000 miles per hour?" His dad hadn't known that, but he was pleased with his son's advancement.

Around the time he ran out of books and magazines on the subject, Frank also reached the limits of his little telescope. His father more than kept his word. Before Frank had gotten far in high school, his father invested in a new Tasco brand reflector, ten millimeters larger than the old scope and with better resolution. It was a fine telescope, so fine that Frank wanted to use it more often. But sometimes the weather didn't cooperate. Frank, following his father's path, had developed skills working with his hands and decided he needed to shelter both the telescope and the friends he invited over to look through it. He

promptly built himself a little backyard observatory at their new home, a small fixer-upper in the Belmont-Cragin neighborhood on Chicago's west side.

The observatory was a small wooden tool shed. Frank improvised a sliding roof for it. Several people could crowd inside around the telescope. Frank's stargazing parties opened his friends' eyes to the glory of the night sky. He aimed the lens at the gas giant Saturn, more than 700 million miles distant, and one friend who looked through the eyepiece was flabbergasted. "Oh, my gosh, that can't be real. You can see the rings! That's got to be a color slide you've got in there."

Always looking to improve the experience, a trait that would stay with him into adulthood, Frank soon set out to build a much bigger telescope—a ten-inch reflector based on a design he'd found in a book. His parents helped him order the lenses, and he built the barrel of the telescope himself. He began using it so quickly that he never got around to painting it. When that telescope was up and running, he gave the Tasco to a friend who seemed interested. There were times in later decades, especially after his father died, when Frank wished he'd held on to that scope. He felt sentimental about it, and yet he was happy someone else was putting it to good use.

At the dawn of the 1980s, Frank was feeding his passion for knowledge of the skies by watching a new public television series, *Cosmos: A Personal Voyage*, hosted by Cornell University astronomer Carl Sagan. The immensely popular series featured imaginative depictions of scientific topics and Sagan's plain-English commentary on the mutual evolution of humankind and the universe.

Years later, in 2014, Frank also would be a fan of *Cosmos: A Spacetime Odyssey*, a follow-up to the original hosted by astrophysicist Neil deGrasse Tyson. The new series made clear that Tyson, a native of New York City, was drawn to the heavens much as Frank had been while growing up in Chicago. As adults, both would run planetariums, although Tyson directs the much larger Hayden in Manhattan. And Sagan, who inspired

teenaged Frank from the TV screen, became Tyson's real-life mentor.

The original *Cosmos* enraptured the youthful Frank. In his life so far, he had viewed thousands and thousands of stars. Sagan lectured about the "billions upon billions" of stars contained within each one of the billions and billions of galaxies our biggest telescopes could see. The scale of the "cosmic all" came into sharp focus for Frank, as if he were turning a mental adjustment knob.

Maybe it was just coincidence that Frank's personality of calm, soft-spoken wonderment mirrored that of the down-to-earth yet starry-eyed Sagan. Frank still didn't think he had the chops to become a professional astronomer, much less an astronaut. But following Sagan's example, Frank personalized his vision and soon took advantage of a family project to bring his enthusiasm home.

One day Frank's dad asked for help putting up a wall in the basement of their Belmont-Cragin home. He wanted to create more space for the growing Kovac family. Frank, along with his dad and uncle, constructed a divider that closed off what would become Frank's new bedroom. As the two older men worked, Frank watched and followed suit. He again discovered that despite being a slow learner in school, he learned fast when he had a vision and could work with his hands to achieve it.

Not long after he moved into his new room, Frank began having decorating ideas. *Cosmos* had inspired him to be with the stars as often as possible, and his parents had no objection. He found some glue-backed luminescent stars at American Science & Surplus, a regional chain store that he frequented, and stuck them above his bed. When the lights went out, the low ceiling was transformed into an expansive sky.

Next, Frank took things further, focusing on the outer basement wall facing his bed. At the same science store, he found bottles of fluorescent paint, including types that reacted to ultraviolet light and "ultra-glow" paints that would absorb regular white light and shine for hours afterward in the dark. The

A close-up of the Saturn mural that Frank Kovac painted on the wall of his bedroom in Chicago.

project required a month of effort. After school, homework, and dinner, Frank would get busy for an hour or two. He used dark paint to frame out the border of a "viewport," matching the hexagonal viewing screen on the imaginary starship Sagan used as a prop in his star tours on *Cosmos*. Inside the viewport frame, Frank painted a large mural of the ringed, color-banded gas giant Saturn, based on a real photo radioed back by the *Voyager* space probe. Then he painted several of Saturn's moons. He added a comet as garnish, then dabbed in a star field. Frank did most of his painting freehand. He used a pail to trace the circle of Saturn.

The celestial objects in his mural created with the UV-sensitive paint glowed when he shined a black light on them. Other objects, done in the ultra-glow paint, shined of their own accord. The black-light images were brighter, but the soft luminescence from the ultra-glow paint especially pleased Frank. To him, those stars looked more like the real ones in the sky. The glow lasted a long time, and as his eyes adjusted to night vision,

the stars even seemed to attain three-dimensionality, as if he were peering through the viewport of his wall into deep space itself.

Frank and his younger brother Matthew often would lie side by side on Frank's bed and observe the space-scape window while listening to cassettes of New Age music and songs from the *Cosmos* soundtrack. It was a multimedia trip, one that was for them every bit as thrilling as the finale of the movie *2001: A Space Odyssey.*

Sometimes Frank would fall asleep that way. Other times his mind raced, reliving the thrills of discovery and wonder that had led him from those early Adler Planetarium visits to building his own observatory and telescope. Here in his modest bedroom, he had created a tiny planetarium, a shrine to his desires. But a newer, bigger plan was forming in his mind, one based on his love of astronomy and all the dreams he'd already realized. *Someday,* he thought. *Someday.*

FROM HUNGARY TO THE STARS

Limitless undying love which shines
around me like a million suns
—John Lennon, *"Across the Universe"*

Frank Kovac orchestrates his symphony of stars for an evening audience sitting on a circular bench fixed to the floor beneath his giant, rotating wooden globe. It is chilly outdoors but toasty here inside the Kovac Planetarium in Monico. The audience numbers thirty-five, mostly elementary-school-age children plus eight parents and other adult chaperones. Led by Pastor Mike Spaude and his wife, Rachel, the troupe has carpooled from Ascension Evangelical Lutheran Church in Antigo, about thirty-five miles to the south.

The globe above the church group is pitched at an angle of 45 degrees, just like its entrance, an aperture sliced from the lower latitudes. Frank stands in the center of the floor, running his planetarium presentation from a cramped, chest-high control station covered in custom-made mirrors that dance with light. "What do the mirrors have to do with astronomy?" a child asks. "Nothing," Frank says. "They just look cool." And they do, despite their vague resemblance to wall decorations in a 1970s disco club.

From the one-man control station, a polyhedral kiosk that looks like a minibar, Frank turns out the lights, and as everyone's eyes adjust to night vision, thousands of bright dots gradually appear on the dome overhead. They glow in a lumines-

cent blue softness that seems to brighten as time passes. "This whole place is here because of glow-in-the-dark paint," Frank tells his audience. He reassures them that the paint is safe and not radioactive, unlike what you'd find in, say, an old luminous-dial radium wristwatch.

Twelve years after the crash of this mostly wooden globe, sixteen since the collapse of an earlier plastic one, and nearly three decades after he painted a star-scape on his bedroom wall in faraway Chicago, Frank A. Kovac Jr. has nurtured his passion as the sole proprietor of the Frank Kovac Sr. Planetarium.

The Kovac Planetarium is a white metal building on a concrete pad fronted by a large gravel parking lot. The lot is surrounded by trees and a narrow road leading up a small hill from nearby US Highway 8. An A-frame portico and double doors lead into a large open room that takes up nearly all of the 2,208-square-foot building. The planetarium proper consists of Frank's twenty-two-foot rotating globe in the center of the room. The building's inside walls are made of blue corrugated sheet metal with exposed support beams and crisscrossing cables. The space feels orderly and professional, yet playful and inviting.

Around the sides of the room sit astronomy displays, including star photos and maps, fanciful mobiles of stars and comets, and a photo of Albert Einstein. Also there's a compact photo presentation on the construction of the planetarium. Inside each restroom, visitors find a modern sink and toilet framed by checkerboard tile and wallpapered with another star field and a border of fanciful images of planets, a space shuttle, and astronauts. The restrooms are scrupulously clean, like everything else in this building.

Frank's office takes up one corner of the main room. The office has an open design, with a desk, a computer workstation, file cabinets, and a waist-high divider that also serves as a service counter where Frank sells tickets and takes reservations.

Frank greets his guests with a smile and often a handshake. His default expression is that same, seemingly effortless smile.

He's in his late forties but looks years younger. He dresses casually, and his slightly thinning sandy-brown hair falls over the tips of his ears and curls at the nape of his neck.

The globe is an impressive sight for first-time visitors. It hangs from a twenty-five-foot-high ceiling on a giant spring and rests on an angled base ring fixed to the floor. The ring has a set of wheels. Underneath the globe in a mini basement, an electric motor provides rotation, making the wooden globe creak slightly as it moves. The globe rotates over and around a stationary floor framed by the circular bench. Above is the star dome, a blank white when the lights are on. When Frank turns them off, the dome glows with convincing starlight.

Except for the dark trim of its wood-and-metal ring, the globe is painted white, inside and out, giving it a sleek, futuristic look. But Frank has added an anachronistic touch: a pair of ornate brass lamps frame the globe's circular portal. Patrons approach via a railed ramp, carpeted in dark fabric that makes the globe stand out even more. From the modern, industrial feel of the exterior, patrons pass through the globe's portal and into the interior. Courtesy lighting along the back of the circular bench gives the inside of the dome a pinkish sheen, suggesting dusk.

Using a red laser pointer, the owner and sole employee of the Kovac Planetarium proceeds to point out and describe for his paying audience various constellations and stars, and the encircling fine white mist of the Milky Way galaxy. The star field faithfully reproduces what the unclouded night sky outside over Monico would show this time of year.

Listening to Frank, visitors might detect in his speaking pattern a certain echo of the earnest, soft-spoken Carl Sagan. As he talks, he occasionally turns on the motor, rotating the surrounding globe through an entire "evening" of viewing a few seconds at a time. A full revolution, which at top speed would take about a minute, represents twenty-four hours, during which time the stars rise and set. The sky dims as dusk ends and brightens as morning approaches thanks to the dome's lighting system. In

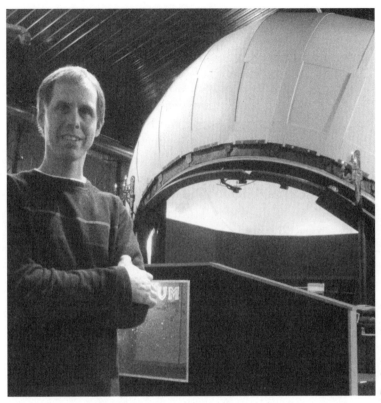

Ron Legro

The planetarium globe is Frank Kovac's pride. Photographed in 2013.

between, Frank uses low-tech yet surprisingly effective optics to make an occasional meteor race across his artificial sky.

Frank points with his red beam high overhead where a dot of light represents the North Star. "That's called Polaris," Frank explains. "It was there before the snowmobile." The reference to the popular brand of winter recreation vehicles draws laughs from the Wisconsin crowd.

At one point Frank shows slides of himself building the very globe that now surrounds them, a project that took him nearly eleven years and led him down many a winding turn. His history of the planetarium depicts various stages of con-

struction; he points out the nuts and bolts that hold his wooden sphere together and the giant spring, connected to a beam in the ceiling, that supports the globe.

Frank's years-long quest to build the planetarium, whatever the personal cost, echoed his family's history of restless questing—evading persecution; walking across rugged, enemy-infested countries in post-World War II eastern Europe; finding a path to comparative safety and opportunity in America.

The planetarium's audiences range from young children to seniors, but Frank most appreciates the kids, who sometimes seem very informed about the universe, even throwing him off guard with tough questions. Third to fifth graders are his favorite age group. "They like to ask questions, and they're reasonably smart already," Frank says. "Once they get to high school age, they don't ask."

A boy in this session interrupts his presentation: "So is the sun a star?" "Yes, it is," Frank replies.

One little boy once told Frank that when he grew up he wanted to rocket to Mars. So did Frank at a similar age. In these fresh faces he sees a bit of himself, that same sense of wonder and high curiosity.

Before the supposed Mayan end-of-the world scenario in December 2012, young children would ask Frank if the prediction was true. Frank always said no. "Oh, thank you, Mr. Kovac," one girl replied. "I don't want to die yet."

Frank finishes his sky survey and then gets ready to really wow the youngsters. "One more thing. This is a kid thing; we have a lot of kids here and we can all be kids once in a while. This is not very educational, but I know you'll like it. This is my homemade laser show." He cranks up a throbbing New Age tune on a stereo and flips on his light show. Like everything else Frank has created for this place, it is homemade yet functional and satisfying. His special effects depend on a couple of surplus programmable lasers, the turntable of a phonograph, a glass saltshaker, and a water bottle. When he aims a light at

the bottle, the result, refracted through the fluid, resembles the shimmering aurora borealis.

Oohs and ahhs erupt from the kids as Frank's lasers trace rapidly moving geometric figures on the dome. "Happy Valentine's Day, everyone!" Frank shouts as the lasers trace a red heart. By the end, the audience is clapping along in rhythm as the lasers draw ever more complex patterns and exclaiming, "Wow!" "Really awesome!" "That is so cool." And in a corner of his mind Frank pops right back to a night in the 1980s, when he and a few teenage friends gazed upon his painted bedroom wall star-scape, issuing their own superlatives while listening to *Music from the Hearts of Space* on FM radio.

Frank Anthony Kovac Jr. was born the second of five children on September 12, 1965, in Chicago, Illinois. His mother, Mary, ran the house while Frank Sr. worked as a maintenance man in their apartment building in the city's Lincoln Park neighborhood. The Kovac side of the family was of German-Hungarian extraction, living in a region included in postwar Yugoslavia. As World War II loomed, the family changed its surname to Kovach (the rough equivalent of Smith in English) in an effort to avoid persecution. But changing their name didn't afford full protection from the horrors of war and intolerance. For a while, the Kovachs slept on straw and threw rocks at pigeons in hopes of bringing down some soup meat.

Nor did persecution end with the war. Yugoslavian president Josip Broz Tito had fought the Nazis, but his policies gradually aligned with those of the Soviet Union. Strife and mistrust persisted in the region.

When Frank Sr. and his brother Mike were still just boys, their father and Mike were taken by Russian soldiers and sent by rail to prison camps. Their father was never seen again, but eleven-year-old Mike managed to escape his train when it stopped

briefly, hiding on the tracks as it slowly departed over him, Mike pressing himself into the ties.

Mike Kovach spent three years wandering on foot across Eastern Europe in a zigzag hike toward the West. One time, he hid while soldiers forced prisoners to dig their own graves before shooting them. Eventually, with help from a doctor, who bought him a suit; a British resettlement camp; and an uncle living in Akron, Ohio, Mike found his way to the United States as a refugee.

The family surname evolved still further into "Kovac." Mike, however, kept the "Kovach" spelling. He first settled in Akron, Ohio, and eventually he married and moved to Crandon, Wisconsin, where he and his wife, Christine, bought a motel several miles east of Frank Jr.'s eventual place in Monico.

In 1958, twenty-year-old Frank Sr. followed his brother to the United States from Yugoslavia. Not long after Frank Sr. arrived in Chicago, he met his future wife, Mary Rongish, a Kansas native, at a lakefront air show. Frank Sr. spoke little English, but Mike and Christine were on hand and translated Frank's interest in arranging a date with Mary. They exchanged phone numbers and met again a week later. Six months later, they married.

The couple stayed in Chicago and went on to create a close-knit, supportive family. Frank Sr. eventually learned English and became a citizen. He and Mary and raised four sons and a daughter, coping with developmental issues in two of their boys. Their eldest son, John, eventually settled near Kenosha, Wisconsin, and raised two girls with his wife, Cami; Steven died at age thirty-three; Matthew, who is three years younger than Frank, lives with their mom at the family's Chicago home. And the youngest, Kathleen, came to live with Frank for two years in Monico in 1999. She fell in love with a local man, Rob Meyer, and married him. They settled and raised their children a few miles west of Frank's place.

Frank Jr.'s first visit to the impressive Adler Planetarium at age five wasn't his only momentous event that year. He, John, Matthew, and others in their group escaped injury one day when

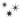

The Kovac family posed for a portrait around 1994. Back left to right: mother Mary, eldest son John, father Frank Sr., Kathleen, and Matthew. In front, Frank Jr. embraces his brother Steven.

neighbors of the Kovac family took the boys to the top of Chicago's hundred-story John Hancock Center to view an air show. Afterward, the group was riding back down in an elevator when a cable snapped. The elevator dropped nearly fifty floors before emergency brakes brought it to a halt. During the free-fall descent, everyone aboard temporarily experienced weightlessness, and many screamed. Frank, however, does not remember feeling afraid. He felt exhilarated. The incident was not only a harbinger of later crashes involving his planetarium globes, but also was the closest Frank would ever get to experiencing another of his dreams—orbiting the Earth in zero gravity.

John was barely a year older than Frankie, as family members called him. The brothers liked to go fishing together in the nearby Lincoln Park lagoon, although, as time went on, Frank more often brought his telescope than his fishing pole. The two

elder brothers attended Sunday school and took sacraments together at the local Catholic church. They pitched in to assist their younger brother, Stevie, who was autistic and had a hard time getting around, and helped their parents with household chores. They also helped their father with building maintenance duties such as sweeping stairs and shoveling snow.

When they were having fun together, "Frankie was driven," John recalls. "He had fierce competitiveness. We used to play video games and if he lost, he got really upset."

Frankie also liked building things. The Kalmars lived upstairs from the Kovacs in Lincoln Park. Frankie and John often visited them. Soon, the childless couple became informal godparents to the Kovac children. The Kalmars saved their yogurt cups, which Frankie liked to deploy as construction blocks, erecting towers and other miniature structures. Frankie gained a new nickname: the Builder.

As he entered his teens, Frank's interests widened. He preferred spending more time at home, working on projects with his dad and digging into books. But he wasn't a complete bookworm. He learned how to swim at a young age. He skateboarded, flew kites, and rode his bicycle. Eventually he would bike alone, through heavy crosstown Chicago traffic, sometimes at night, to visit the Adler Planetarium.

Another of his pastimes, which turned into a vital skill decades later, was tree climbing. The kid who had weathered a fifty-story elevator fall couldn't resist scaling trees—the taller the better. But astronomy increasingly became his primary interest. "Astronomy kept me out of trouble," Frank recalls. "It kept me focused on how small we are. I was absorbed into the universe."

Mary's wholesome meals were shared around the family's kitchen table, the main arena for conversation and planning. Frank Sr. was a supportive, available father—in John's words, "a good guy" and not the sort to complain. But he was bothered by his children's disinterest in learning and speaking Hungarian. The kids became, as their father saw it, "stubborn"

English speakers. Despite the challenges, Frank's close family made a habit of helping each other out then and in years to come.

In warmer months, the family went on outings and camping trips, often to Wisconsin and sometimes to the far northern woods. The father told his children how camping under those Wisconsin skies reminded him of the vivid, star-speckled night skies he saw as a child. There was another similarity: Though electric power served virtually the entire state by the late 1960s and early 1970s, many rural Wisconsin residences and cottages still harbored woodstoves and kerosene lamps. It felt like home to Frank Sr., bringing back the best feelings and memories from a mostly stressful young life. "When we came to northern Wisconsin, he called this the old country," Frank remembers.

When their Lincoln Park apartment grew too small for the rapidly expanding family, Frank Sr. purchased the house in the Belmont-Cragin neighborhood. Frank's eventual high school, a vocational school later named Prosser Academy, was right across the street. Frank's dad moved the family to the house even though it was a fixer-upper and he had to drive miles farther through bad Chicago traffic to get to his job. "It was so we could go to a good public school," Frank recalls. "My dad thought that everyone should learn to work with tools."

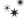

As the energized crowd from Antigo claps, Frank brings his planetarium lecture to an end. As typically happens, Frank's guests, even many of the children, line up to shake his hand and thank him. Pastor Spaude approaches, and Frank asks how he learned about the planetarium. "We heard about it from some of our members," Spaude replies. Of course. Word of mouth is the main way visitors discover the Kovac.

When visitors depart his planetarium, they occasionally notice the small crucifix that Frank has positioned above the outer doorway. He doesn't comment on it unless someone asks, but he's happy to discuss his religious faith. He likewise avoids

including religious views in his presentations, focusing instead on what science has learned of the universe and the wonder of it all. But he's not above throwing in an occasional religious reference to some historical astronomical event, and he did so in the presentation to the Antigo church group. At one point he referred to the Pleiades star cluster's being mentioned in the biblical book of Job; at another point he cited astronaut and Wisconsin native James Lovell Jr. who aboard the Apollo 8 moon expedition in 1968 radioed back a Christmas Eve reading from the Book of Genesis. Frank tailors his presentations, which are completely unscripted. Pastor Spaude smiles, saying, "He knows his audience."

Frank explains that, due to the cosmic subject matter of planetarium programs, audience members often raise questions regarding the role of the deity, the age of the universe, the "big bang" theory of universal creation, evolution, "and even aliens." Frank focuses on the science but doesn't shy from faith-based inquiries. "When Pastor Spaude came here with his group he initially mentioned the significance of the six-day creation of the universe," Frank recalls. "I myself believe that the universe was created by God, yet over billions of our years. Many religious groups fear the word 'billions.' Saying God did all this in six twenty-four-hour days only limits the wonder of the creation. God is not limited by time." It hasn't escaped Frank's attention that many of his guests, even if they understand the actual science, seem to love the idea that, at least here in the motorized globe of the Kovac Planetarium, the universe revolves around them—matching conventional although erroneous beliefs that persisted throughout most of history up to the Renaissance.

It still amazes Frank that, years after opening, his remotely situated planetarium attracts thousands of visitors every year. Along with neighbors, colleagues, and relatives, these visitors and the stars overhead constitute the key relationships in his life. By deciding to build the planetarium in such an isolated locale, Frank knew the project might impede relationships, especially the romantic kind that might otherwise have come

along. And there were times when he paused to ask himself, "What am I doing?" But the compulsion to pursue his dream trumped everything.

"Most likely it's why I stayed single," he observes. "If I'd had a family already, they would have been first, before I spent thousands of dollars on this. Had a few dates here and there, but that didn't work out very well. Don't want to get sidetracked, here."

Several visitors sign the guest book on Frank's counter, already packed with signatures and testimonials from previous customers. And he keeps a book of special messages people have sent him. Typical among them is a disc-shaped, hand-lettered and decorated thank-you message featuring a photo of several dozen first and second graders posing in front of the planetarium building.

Frank keeps the hundreds of thank-you notes and cards he's received from all over the world, and each one seems special. Although he has become accomplished at speaking to groups of strangers and presenting astronomy, it still impresses him that people like his show. It validates everything he has done to get to this point.

Waving farewell to his Antigo audience, Frank is once again living his dream. A straggling boy from the church group pauses on his way out to the parking lot and the idling van that will take him and the others home from Monico to Antigo. "How long will the sun burn?" the boy asks Frank. And Frank provides reassurance: "A long time. Yeah, it's going to die, in time, but not in our lifetime. So we're okay."

Another visitor asks if there is intelligent life elsewhere in the universe. It is mathematically possible, Frank explains, "but you have to be in the right place at the right time. And there's a lot of space and time. But that means it will happen, somewhere, in all likelihood. This," he says, pointing to the planetarium around them, as if to emphasize that anything is possible almost anywhere, "happened in northern Wisconsin."

OFF HE GOES, INTO THE WILD BLUE YONDER

Leaving thine outgrown shell by life's unresting sea
—Oliver Wendell Holmes, *The Chambered Nautilus*

When Frank Kovac Jr. graduated from high school in 1984, his life's course seemed as charted as the Earth's annual loop around the sun. In the spring, even before receiving his diploma, Frank began to work half-time at the S&C Electrical Co. on Chicago's north side. It was part of a cooperative vocational training program approved by his school. Frank's schooling and natural mechanical bent served him well at S&C. After graduation, he landed a full-time job making steel brackets used to attach transformers to utility poles.

But as Frank entered his middle twenties, toiling away at S&C, a pronounced restlessness grew inside him. His mind wandered through and became increasingly familiar with the universe, but his day-to-day existence narrowed, constrained by family and work. "After three years of production machining work, I had become very bored of the job. I felt stuck," he recalls. "It was just the same thing every day, drilling holes in parts." Beyond that, he was still living with his family, and the ten-mile commute each way through Chicago's rush-hour traffic was a grind.

As he would often do when looking for a new challenge,

Frank cast his eyes skyward. In 1988, he decided to join the US Air Force. If he couldn't be an astronaut, at least he could find another way to have his country support his star-focused dreams.

"I had a desire to see other places and looked at the military as a way out," he says. "My boss was very angry with me when he learned that I'd signed up for the military. He did everything in his power to try to change my mind, to no avail. My parents were very supportive of me."

In November 1988, shortly after turning twenty-three, Frank turned his back on the factory floor and left for six weeks of basic training at Lackland Air Force Base in San Antonio, Texas. His backyard observatory under the spreading apple tree became the family's garden shed. He never again lived full-time in Chicago.

After basic training, in January 1988, Frank was sent for three months to the Air Force Technical School at Lowry Air Force Base in Denver, where he became acquainted with the B-52 bomber. He learned to arm the aircraft with nuclear bombs, a skill that, surprisingly, would become useful later in civilian life. As a newly trained airman in peacetime service, Frank could look forward to being posted anywhere around the world with minimal risk. Exotic locales such as Europe or Hawaii beckoned, but Frank wanted to stay within driving distance of his family in Chicago. He had his eye on a place more mundane, a location some in the air force derisively called Siberia— K. I. Sawyer Air Force Base near Marquette in the Upper Peninsula of Michigan.

Frank's desire to be sent north flowed from the same motivation as much else in his life—his love affair with the stars. Sawyer was in the sparsely populated, heavily forested UP, full of clear skies and excellent for stargazing. The location had another particular draw for the young airman—it was only about three hours from Monico, Wisconsin, and since 1985 Frank had been buying land in that obscure town.

He had become familiar with the area when friends had

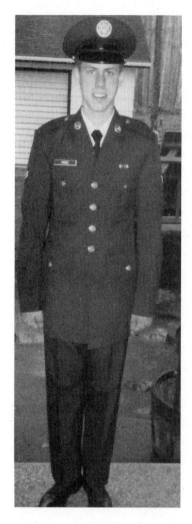

Frank Kovac in his air force uniform.

taken the Kovac family to northeastern Wisconsin for vacations in his childhood. A year after graduation, at age nineteen and relatively flush with his earnings from S&C, Frank took his brother Matthew on a road trip to the area in a Chevette. They dropped in on real estate brokers, who, once they got past Frank's youthful appearance, were happy to show him land. What makes property in the North Woods pricey is lake access, but Frank wasn't seeking a lovely shoreline view or boat pier: the more remote the land, the better for him. When an agent warned him they were going to look at old hunting camps in the middle of nowhere, Frank said, "That's perfect."

"Most of the property around here was reasonably priced because it has swamp mixed in with some higher spots," he recalled during a tour of his domain years later. "But it didn't matter to me; I wanted to see what was above. I looked up, and before buying the property I came out at night." So Frank bought that unprized land, beginning a spree that eventually placed his name and signature on more than a dozen documents in the dusty archives of the Oneida County Courthouse in Rhinelander.

In May 1988, Frank reported to Sawyer for a tour of duty that would last until he left the air force. He maintained aircraft equipment and became the number-two man on a five-member bomber loading crew, obtaining a security clearance to handle weapon systems. He made sergeant in January 1991. A few months before that, in October 1990, Frank moved off base, twenty-four miles south to a small trailer in Little Lake, Michigan, a town not unlike Monico. About half a dozen times a year, he visited his family in Chicago, a drive of more than six hours. And he spent many weekends on his land in Monico.

Frank thrived in the air force, but he says he was bothered by the lack of control over his destiny. "In the civilian life, we are free to a certain extent when making decisions about our future. In the military, somebody else makes the decisions," he says. In July 1991, he left the air force with an honorable discharge and moved to Monico for good. Four years later, Sawyer AFB closed.

That was not the end of his military service, however, as the air force encouraged him to join the reserves. He did so about a year after his discharge and was assigned to the 440th Airlift Wing at Mitchell International Airport in Milwaukee. His duties involved training on the C-130 cargo aircraft. He served one weekend per month, plus two weeks of active duty per year. During that time, he was promoted to staff sergeant and traveled as far as Hawaii.

After two years in the reserves, Frank decided not to re-enlist. "I was no longer interested in loading cargo planes," Frank says. He was tired of fulfilling his monthly obligation in Milwaukee, especially because it took time from doing exactly what he wanted to do with his newfound freedom—improve his property and watch the stars.

Slowly but surely, Frank was becoming part of Wisconsin's North Woods.

4

OF HODAGS AND PONIATOWSKi

> The beauty encourages creative urges when
> artistic passion and nature converges
> And out of the studio soon it emerges the
> world's biggest muskie of paper maché ...
> Wherever you look there's a lake to be
> trolling, a trail to be hiking, a beach
> to be strolling
> And likely as not there's a place to go
> bowling nearby that sells sausage and
> bait on the side
> —Lou and Peter Berryman, *"Forward Hey"*

US Highway 8 is a classic road, a mostly two-lane, east-west route that crosses northern Wisconsin roughly along the 45th parallel, meandering past farms, lakes, forests, and rivers between the Minnesota border and Michigan's Upper Peninsula.

The rolling countryside is beautiful, with eagles swooping low and deer charging in front of motorists with alarming frequency. Miles go by with no signs of civilization other than the occasional gas station, farm, or tavern, or when the highway passes through small communities like St. Croix Falls, Tomahawk, Rhinelander, Crandon, or tiny Monico, population 309.

By building his celebrated structure in the North Woods, Frank Kovac borrowed from—and contributed to—the folksy yet surprisingly diverse culture of Wisconsin's northern communities. The big-city boy who grew up amid urban hustle and bustle geared down, adapting to the slower pace of life while

coming to revere the solitude of the bucolic North Woods. The majesty of its skies he had long since come to treasure. It was quite a transformation, and yet, in that last respect, Frank's love for northern Wisconsin was born and bred while he lived in the City of Broad Shoulders.

Chicago and Monico may seem incongruous, but with twenty-first-century US culture becoming more interconnected—the lack of interstate highways in some places notwithstanding—it would be a mistake to imagine that Wisconsin's sparsely populated North Woods are some kind of cultural backwater.

Residents of rural Wisconsin often think urban dwellers believe life in the north to be leisurely, affording plenty of time to hike, fish, and ski. That is according to a study by Katherine Cramer, a political scientist at the University of Wisconsin-Madison. Rural residents, on the other hand, think they are underpaid and overworked, with too little time to enjoy the bountiful attractions around them. They see themselves as more likely to work in tourism than to be tourists and have developed a love-hate relationship with the urban droves and the dollars they bring to the region.

Although Wisconsin remains segregated politically, racially, and economically in some areas, it has nevertheless continued to evolve in its ethnic diversity, much like the rest of the country. The city of Wausau, an hour's drive from Monico, is a paper-making and manufacturing center. According to the 2010 US Census, 11 percent of Wausau's thirty-nine thousand residents are Asian Americans, mostly Hmong immigrants.

As in many places in the United States, European immigrants came first to the region, colonizing and displacing centuries-old Native American cultures. For one hundred years, beginning mostly in the mid-nineteenth century, Germans, Poles, Scandinavians, and others who settled in Wisconsin focused on life-sustaining farming and logging. Back then, most of northern Wisconsin consisted of almost impenetrable virgin forest—pine and balsam, maple and oak, ash and aspen. But overharvesting of the forests into the early twentieth century changed that.

View of the giant walk-through muskie and other over-sized fish at the National Fresh Water Fishing Hall of Fame & Museum in Hayward, Wisconsin.

Today only one percent of the state's virgin forests remain, though reforestation efforts have helped Wisconsin's woods recover; forest land now encompasses some twenty-seven thousand square miles, nearly half the state. Dotted with many of Wisconsin's 15,074 lakes, the North Woods are an increasingly frequent destination for vacationers and tourists from Milwaukee, Minneapolis, Chicago, and other cities.

Before freeways and the mass marketing of tourism opened the area in the late twentieth century, most amenities were modest. Small, unheated cabins were common, as Frank would find out. Demand for more luxurious accommodations rode in with the superhighways. And promoters saw a need to augment the lure of the region's natural beauty with, well, bigger attractions. Before McMansions and skyscrapers, this was Wisconsin's way of living large.

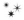

A large statue of a Hodag sits in front of the headquarters of the Rhinelander Area Chamber of Commerce.

Others have written about the plethora of gigantic tourist draws scattered across the region, of which the Kovac Planetarium is now one. A fascination with eye-catching bigness also characterizes tourist attractions in other states, but Wisconsin seemingly couldn't erect enough of them. For instance, as the folk-singing Berrymans note, a gigantic muskellunge greets visitors to Hayward's National Fresh Water Fishing Hall of Fame & Museum. The ersatz fish is four stories tall and as long as a jumbo jet. You can walk through the muskie, billed as the world's largest fiberglass sculpture the artistic license of the Berrymans notwithstanding.

Not far from the Kovac Planetarium, in Rhinelander, resides a giant roadside statue of the Hodag. The creature, a mythical chimera with fangs, horns, and spikes down its long tail, even serves as the mascot for the local high school athletic teams. Supposedly discovered in 1893, the Hodag is really just a character from a tall tale, the region's version of the Loch Ness Monster or Bigfoot.

Wisconsin's North Woods also reveal numerous outsized statues of fabled lumberman Paul Bunyan and Babe, his blue ox. And some years back an entrepreneur built a gas station south of Antigo on US Highway 45 whose convenience store was shaped like the head and upper torso of a gigantic badger, the state animal. Cars pulled up to gas pumps inside an enormous

hollow log with a massive red squirrel perched on top. Although the gas station went out of business years ago, the log and squirrel are still there, and the badger with its outstretched paws now greets patrons of a "gentlemen's club."

Giant chickens, giant Native Americans in battle dress, giant everything. So much of this statuary exists that the west-central Wisconsin city of Sparta even has a gigantic graveyard for surplus and abandoned sculpture giants repossessed from state roadsides.

Frank Kovac's spinning, hollow-globe planetarium isn't quite as imposing as a fish sculpture so big it could swallow a semi-trailer, but it's nevertheless iconic, gaining honorable mention on the list of "Seven Man-Made Wonders of Wisconsin" compiled by Travel Wisconsin, the state's official tourism website. Ahead of the planetarium is stiff competition, including two world-renowned architectural wonders: Taliesin, architect Frank Lloyd Wright's self-designed Prairie School-style home near Spring Green, and the movable, winged roof of the Milwaukee Art Museum's Quadracci Pavilion, designed by Santiago Calatrava.

The state's promotional style evolved mostly in the post-World War II era as visitors took advantage of better highways, making Wisconsin a four-season playground, haven to snowmobilers, golfers, anglers, boating enthusiasts, hikers, bikers, and campers. Tourists in the lake region pumped badly needed money into the North Woods, where the permanent population had dropped as a result of the decline of the railroads, logging, and paper making—although Wisconsin is still the nation's largest paper producer.

Despite growth in tourism and business development, northern Wisconsin remains a region where the entire population of several counties, including Forest County, which borders the town of Monico, reaches only four figures. But the year-round residents still somehow manage to make a living, and many are disinclined to move away from this placid region where glaciers left so many waterfalls, rivers, and flowages that some have never been named.

The area around Frank Kovac's land includes 650,000 acres of the Nicolet National Forest. The Sokaogon Band of Lake Superior Chippewa run a casino on their small reservation at nearby Mole Lake. To the east along narrow State Highway 32, a once sleepy two-laner, an arts-and-crafts industry now thrives, along with wineries and cheese makers. Close by, Crandon's International Off-Road Raceway stages a pair of annual dune buggy and truck races that draw nearly ninety thousand spectators. For the more nostalgic, nearby Laona offers a ride on an old-fashioned steam train. In the hamlet of Pearson, twenty-five miles south of Monico, tourist listings urge passersby to come experience the Dirty Dog Dryland Derby, a warm-weather sled-dog race. Yes, in Wisconsin, land of deep-snow winters, some dog sleds run even in the warmer months.

Festivals and county fairs also abound. Some of the bigger ones now book big-name acts like the Nitty Gritty Dirt Band, because, even though a typical northern county's entire population couldn't fill a fraction of the seats in Green Bay's Lambeau Field, home of the National Football League's Packers, culture-savvy locals still expect big-league entertainment for their money.

Other signs of the region's prideful culture are the many modern and high-performing public schools and the architecturally impressive courthouses gracing county seats. In other states, some of these courthouses might pass as state capitols. The stained-glass dome of the Oneida County Courthouse in Rhinelander is such a fine example of the Classical Revival style that the building is listed on the National Register of Historic Places. Bigger cities in the region, like Antigo, population about 8,300, and Rhinelander, home to about 7,800, also feature a number of relatively well-appointed museums that recount the general history of the area and explore topics such as steam trains and lumbering. And, of course, visitors can also visit the Kovac Planetarium, which fits right into an evolving theme of Wisconsin attractions that are not just fun but also educational.

By reputation, northern Wisconsin's residents are seen as taciturn, spiritual cousins of the Norwegian bachelor farmers

featured in Garrison Keillor's *A Prairie Home Companion* public radio show. Those traits surely arose from the self-reliance, understatement, and even stoicism that made hardscrabble farming in these parts tolerable. As recently as the 1960s, the state's official tourism slogan was the laconic, understated "We like it here." So it still feels a bit unusual to hear small-town Wisconsinites bragging about their state and their communities.

Nevertheless, residents and civic leaders do seem increasingly vocal about their region's heritage and treasures. And in recent years, small-town Wisconsin communities have begun to promote themselves more aggressively. That may explain why the Kovac Planetarium has attracted TV video crews from Canada and New York City—and visitors from around the world.

The planetarium's rising profile also relates to America's growing cultural fusion. In an era characterized by mass media and cheap travel, it is easy to learn about and embrace trends, no matter how different or outré. In the early twenty-first century, high-speed Internet and cable were available only in larger North Woods communities. In the more rural areas, the only Web access was likely to be via satellite dish, smartphone, or old-fashioned dial-up. Today, mass communications allow residents to compare their culture with that of the outside world.

Modern communication also enables talented people to work wherever they like, no matter their profession. Internationally recognized astronomer and astrobiologist Margaret Turnbull lived and worked for several years in Antigo. Noted for her contributions to the Hubble Space Telescope and methods she devised to discover habitable planets in other star systems, Turnbull worked for universities and at NASA. But she also thrived while enjoying nature and the good life in small-town Wisconsin. She and Frank met briefly at a presentation she gave in Rhinelander, around the time Frank opened his planetarium.

And so, aspects of urban culture—for example, big-box retailers and drug use—that once might have elicited sneers from small-towners are now common in rural areas. Wisconsin communities with as few as a thousand residents are proud to be on

the map—not the state highway map, although a freeway exit is almost universally viewed as a big plus, but the map of fast-food franchises. Slightly bigger northern cities treasure their beltway shopping malls, even though these huge developments have often led to the ruination of locally owned businesses on decaying main streets.

Still, some traditions and localisms persist and even thrive. If you're a northern Wisconsin resident, you're more likely than not to go bowling at least once in a while or take your family out to a fish fry on Friday night. And Wisconsinites are fond of visiting traditional supper clubs, which have graced small towns and rural highways throughout the state for nearly a century, in some cases.

Given greater ease of travel and widespread communications, northern Wisconsin no longer is the place of mystery it once was. For a time in the 1930s, the region served as a getaway that was favored precisely because it was so hard to get away to. Gangsters including Al Capone, John Dillinger, and Baby Face Nelson found northern Wisconsin a handy place to take refuge from J. Edgar Hoover's G-men. Capone kept several Wisconsin hideouts, including one upscale resort home featuring a seaplane dock. Unsurprisingly, it became a tourist attraction.

The region's mysteries didn't vanish along with the gangsters. Tall tales and scary stories remain the norm around campfires where tourists, scout troops, and others gather. They may be utterly unafraid of pitching their tents in the deepest, most northern boreal forests, but after climbing into their sleeping bags, they can be forgiven for thinking they just heard a bear sniffing around outside their flimsy tents, because sometimes they're right.

It makes sense that movies and TV thrillers like *The X-Files* have situated spooky stories in Wisconsin's far northern woods. Stories from real-life Wisconsin can out-spook the most phantasmagorical fiction. In 2014, a pair of twelve-year-old girls from a Milwaukee suburb tried to kill a classmate to impress a fictional Internet character called "Slender Man" and then, before

their capture, began walking to his supposed home in the Nicolet National Forest. No wonder, then, that some neighbors and visitors took one look at Frank Kovac's giant globe and wondered which government agency had built it and—no doubt more jokingly—what planet it was going to visit.

One Wisconsin community that shares astronomical publicity with Frank Kovac's accomplishment is Poniatowski. The unincorporated Wisconsin town is in Marathon County, about eighty winding-road miles southwest of Monico. It's a typical four-corner town with just a few homes, a tavern, and a small county park. What makes Poniatowski special is that it is quite close to halfway between the equator and the North Pole while also being a quarter of the distance around the Earth from the prime meridian. That makes its coordinates roughly 45 north, 90 west, which inspired another song from the folksinging Berrymans, whose clever tunes often celebrate rural Wisconsin. One stanza explains everything:

> A quarter of the way from top to bottom of our earth
> A quarter of the way around the planet of our birth
> Speaking cartographically it's not extreme to say
> It's the most important 'towski in the USA.

Monico, to the northeast, wasn't quite as close to that official demarcation, but it was pretty close. And that meant something to Frank Kovac, though perhaps not as much as the landscape itself or the especially dark nights. It was for him a special place, ideal for viewing the real stars, ideal for depicting them in his planetarium. Likewise, the idea of being equidistant from both the North Pole and the equator stirred in him the same kind of pride, which he often mentions in his presentations. It's a point of pride echoed by many Wisconsin towns along or near the 45th parallel, as a long list of local historical markers makes clear across the state.

As it turns out, Poniatowski's claim to fame is based on faulty century-old cartography. Because the Earth rotates, it is not a

perfect sphere, but an oblate one. The planet bulges unevenly at its waistline, and modern science says the true circle of points lying halfway between Earth's equator and the North Pole is about ten miles *north* of the 45th parallel. Poniatowski is about a mile off that originally calculated halfway line. Monico is actually a better fit, being about ten miles north of 45 degrees. Thus, in situating his planetarium as well as building it, Frank Kovac came closer to perfection than even he might have expected.

As a place of science and a top tourist draw, the Kovac Planetarium has helped refine the culture of the area, and so has its creator, says Melinda Otto, director of the Forest County Chamber of Commerce, based in Crandon. "He's a featured attraction. I mean, what he's got out there is so phenomenal," she says. She recalls how a Japanese couple once walked into the chamber's offices and, despite a huge language barrier, soon made it clear which local attractions they wished to see—the Kovac Planetarium included. As to why Frank fits in so well with the area's culture, Otto puts it this way: "His demeanor! He's so calm and laid-back and quiet."

He is also a problem solver and a contributor to the community. Frank's eventual brother-in-law, Rob Meyer, sat on the Monico town board when Frank came to a meeting a couple of years after he bought his property there. Frank told the board that his property and that of his neighbors had never been properly surveyed. He asked that they remedy the situation and plunked down all the paperwork, including the research necessary to achieve the result.

Frank and his neighbors also took it upon themselves to name the narrow lane that serves as their street. "Mud Creek Road" is nothing official, but everyone seemed pleased to have a name they could use in return addresses and, in Frank's case, advertising. And they liked the backwoods feel of it.

Otto says that people in Forest and Oneida Counties feel proud of their association with the Kovac Planetarium, and that this pride comes from more than just the gee-whiz aspects of the planetarium's history and design. It's also a growing rec-

ognition of the planetarium's role as a special place, an institution of science and learning, especially since Frank began attracting field trips. His astronomy presentations have given young people in the region a newfound appreciation for the universe. "Some of my own little relatives say the same thing," Otto said. "We can look up in the sky and see what we saw in the planetarium."

For the most part, Frank has assimilated into the local community while retaining his unique perspective. "Most people here either go to the bar or watch the football games, which is fine. But this," he says, pointing to his globe, "this here is culture."

THE MUD CREEK OBSERVATORY

What is more agreeable than one's home?
—Cicero, Ad Familiares

Frank Kovac settled into the culture of the North Woods after
he was honorably discharged from the air force in June 1991.
Bound for what he expected to be a promising future, he was
no longer the callow youth who had left his job in a machine
shop three years earlier. In his own modest way, he had found
the adventure he sought, but now it was time for a change. "I
needed the discipline from the military," he remembers, "but I
felt I was done." While forcing him to mature and grow emo-
tionally, the military also taught Frank technical skills, albeit
extremely specialized ones.

But one thing that did not change was his lifelong fascina-
tion with the stars. As a civilian he would feed that passion by
moving to northern Wisconsin, a place that since childhood had
aroused in Frank the wonder and longing that Disney World
does in the hearts of many other children.

British author Arthur Ransome wrote in his 1933 novel
Winter Holiday of a young astronomer who takes his small tele-
scope into a makeshift observatory located in a barn. Ransome
could have been writing about Frank when he described his
character's wonderment:

> Those little stars that seem to speckle a not too dreadfully
> distant blue ceiling were farther away than he could make

himself think, try as he might. . . . Distant and huge the stars might be, but he, standing here with chattering teeth on the dark hill-side could see them and name them and even foretell what next they were going to do.

Frank Kovac already knew what he was going to do. After the initial trip to the area with his brother Matthew in 1985, Frank had assembled about twenty acres of land in Monico. He had paid about $17,000 for the property, buying much of it on land contracts in small pieces as he could afford to make deals.

When he settled in Monico, Frank's property included an old mobile home and two unimproved hunting cabins, basic structures without water, heat, or electricity. The mobile home wasn't in good shape, so at first Frank stayed in one of the cabins. He planned to purchase a woodstove while he built a house on the property. But he decided instead to rent a "not very good" apartment above a bar in Rhinelander, according to Jerry, his new next-door neighbor in Monico. Jerry thought so highly of Frank that, years later, when a pair of authors writing their book about the planetarium sought to interview him, he asked them not to use his full name, saying he didn't want to detract from Frank's story and that Frank should get all the credit.

Jerry and his wife, Laurie, visited Frank at the apartment and invited him to live with them as a guest instead. At Jerry's house, Frank pulled his weight, doing chores. "If you'd start up a chain saw, he'd be here in five minutes and start cutting wood," Jerry says.

Frank spent the winter with Jerry and his family and then moved into a modest one-story house he built on the site of one of the original cabins. Another of the original cabins now serves as a workshop, storage space, and carport, as well as home to Frank's dog, Sweetie, a male beagle/shepherd mix.

Jerry and Frank quickly became good friends. Jerry describes Frank as spiritual and religious, generally soft-spoken, and in some ways refreshingly innocent. He also perceives Frank to be friendly yet solitary, and sometimes impulsive.

Frank enjoyed playing with Jerry's kids, sometimes boisterously. Being around children was a comfort to Frank, who had grown up in a large family. After Frank built his house and moved out, he continued going over to Jerry's for dinner, often several nights a week. And when Jerry and family were out of town, Frank stoked their woodstove to keep the place from freezing.

Jerry and his wife also enjoyed stargazing. They often looked up at the night sky from their porch and sometimes would sit out in lawn chairs and watch a meteor shower until three a.m., when Jerry would grab a couple hours of sleep before hauling into work. Frank's fervor for the stars impressed Jerry. So in October 1996, when Frank told Jerry of his plans for building a planetarium, Jerry understood, even though Frank's description of a rotating globe that people would climb into through a hole seemed a little unusual.

Frank believes a hidden hand often helps to guide his affairs, and that finding Jerry was providential. In addition to supporting Frank's plan, Jerry turned out to be adept with tools, in many ways complementing Frank's skills in building the sphere.

After settling in Monico, Frank picked up several jobs. He was a forklift operator at Lake Shore Inc., a Rhinelander manufacturing company, full-time from 1991 to 1995, then worked on the line at Marplex, a pallet manufacturer from 1995 to 1996. There followed a hiatus of part-time work cleaning at a Frito-Lay plant. In March 1997, with Jerry's help, he landed a job at the Rhinelander Paper Company, the area's leading employer. "I got in," he says. "I started out in janitorial work and then I got hired as a storeroom/purchasing clerk, a receiving clerk, a dispersing clerk," he said. "It was a union job." He started out making $10.61 an hour but nearly doubled that by the time he left full-time work at the mill in September 2008.

Coworkers were aware of Frank's passion for the stars. Pat Medvecz, who managed the plant when Frank worked there, says the two talked often when Medvecz walked around the operation. "My memories of Frank are very fond," Medvecz

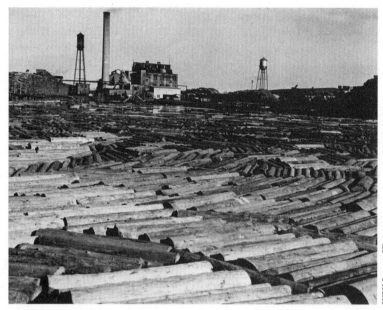

WHi Image ID 5772

Frank Kovac worked at a paper mill in Rhinelander, similar to this one.

says. "He had a passion that maybe is like a lot of people's passion. I know people who were equally passionate about fishing or hunting." Medvecz adds that Frank never came to the attention of his managers for performance or disciplinary issues.

Working in the mill was necessary to fuel his body, but the stars continued to feed Frank's soul. Almost every bit of his leisure time and most of his paychecks went into improving his property so he could better see the heavens. His parents didn't discourage him from living a solitary life so far away from them. Frank recalls that when he told his parents he planned to live in Monico, his father replied, "Your choice."

And slowly but surely, Frank was becoming a Wisconsinite. Consider his style of driving. On visits to Chicago, he would sometimes chauffeur his mom around town in busy traffic. Good Badger that he had become, Frank would slow or stop to let other drivers turn or go by ahead of him. Illinois-bred driv-

ers behind him sometimes became furious at this behavior. "They noticed that Wisconsin license plate on my car . . . I guess I am more of a calm driver now," he says.

Well, mostly. Shortly after he moved to Wisconsin, Frank was driving his mother to a family wedding in Green Bay along State Highway 55 in heavily wooded, tribally owned Menominee County. The road was a two-laner, crossing very hilly terrain. Frank decided to give his mom a thrill. "Watch how it feels when we do about seventy here," he told her. Like many other Wisconsin residents, Frank couldn't resist stomping on the gas way past the posted fifty-five-miles-per-hour speed limit as his car climbed a particularly steep rise, so steep the road widened to allow slow, heavy trucks to get out of the way of other vehicles.

Frank's idea was similar to NASA's legendary "Vomit Comet," an airplane that prepared astronauts for weightlessness by climbing steeply along a parabolic trajectory. After the plane passed the peak of its course and headed sharply earthward, everyone aboard experienced a few moments of weightlessness. For generations, savvy, thrill-seeking motorists have known they can accomplish the same effect by racing up a hill fast enough for their cars to lift off the road, producing the same stomach-tingling effect, but for only a second or two. Frank succeeded in sharing the experience of weightlessness with his mom, but he also got a speeding ticket as he zoomed past a waiting Menominee tribal police car.

Mary wanted to pay the $150 ticket. "Maybe if I wasn't here you wouldn't have wanted to do that," she said. But Frank insisted on paying, saying it was his decision to fly zero-G. "Mom," he explained, "it was just an expensive roller coaster ride."

But that type of amusement was a sidelight to Frank's serious approach to life. Back in Monico, he had chosen to better his view of the heavens by constructing an observatory on his property, building on the experience he'd had with the telescope shelter in the cramped backyard of his childhood home. Thus the Mud Creek Observatory was born, opening in stages

starting in the early 1990s. "It was a rolling roof shed building with a ten-inch telescope in it," Frank recalls. "It was twelve by twelve and the roof rolled back and you had open sky. I don't think I put eight hundred dollars into it." The building lasted until the fall of 2012, when the rail support warped and he reluctantly tore it down. The aim of the project was simple: to allow viewers a clear look at the stars with Frank's encouragement and guidance.

Although Frank is unfailingly polite and considerate of others, his focus remains inward, relentlessly following his internal gyroscope. But when it came to the gospel of his observatory, he turned that drive outward, spreading the word

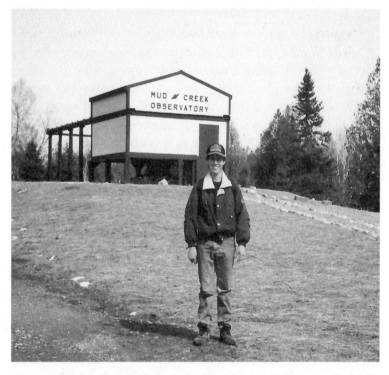

In 1993, Frank opened the Mud Creek Observatory, featuring a handmade ten-inch telescope. In 1994 he bought a 16-inch Orion brand reflector telescope and eventually displayed the handmade original in the planetarium.

far and wide among the sparse population of Wisconsin from
the Michigan border to Stevens Point and beyond, almost al-
ways personally, occasionally through word of mouth. He spoke
to civic groups, church gatherings, and scout troops. To any
who asked, he would make a presentation about the stars, in-
viting listeners to come to the observatory to see for them-
selves. About a dozen a month took him up on it. He charged
nothing, but some visitors left donations.

Frank almost glowed when the groups showed up, staying
up late to get good views, helping them point the telescope to-
ward the proper coordinates, and explaining what they were
seeing. He did so gladly, often learning from his visitors even
as he was teaching them. There was only one real fly in the
ointment: the weather.

Although Monico has wonderfully clean air and very little
light pollution, it is cloudy about 95 percent of the time from the
middle of November to the middle of January, tapering off to
about half the time in the middle of July. Even without com-
plete cloud cover, nearly every other night Frank could not show
his visitors everything he wanted them to see. The situation
bothered Frank and got him thinking that there had to be a
better way.

The result was the resurfacing of an idea that had floated in
the back of his mind for years: building a planetarium. Bringing
that idea to fruition would consume his life for more than a
decade, tax his creativity, and drain his bank account. It also
would become a memorial to Frank Kovac Sr., the man who
had given his son a telescope all those years ago.

OH, CLOUDY NiGHT

**Remember now thy creator . . . while the
sun, or the light, or the moon or the stars,
be not darkened.**
—Ecclesiastes, *chapter 12, verses 1 and 2*

Great ideas typically take a long time to gestate, even when
they appear to erupt in a spontaneous burst of creativity. So it
was for Frank Kovac one night in October 1996 when a cloudy
sky triggered an idea that had been semi-formed deep in his
mind, pushing it through to glorious consciousness. Too often,
groups had visited the Mud Creek Observatory and anticipated
joining Frank for an awe-filled session of stargazing only to be
disappointed by a sky filled with clouds instead.

Frank had done everything he could to maximize viewing
conditions. He built the observatory off a back road in the woods
in the deep country. He chose a place with unpolluted air. He
kept track of the phases of the moon to find the best nights for
viewing stars.

Light pollution was not much of a challenge. The North
Woods had little of the human-made interference common to
large cities. Rhinelander to the west, Antigo to the south, Three
Lakes to the north, and Crandon to the east were small com-
munities that emitted some light into the atmosphere, but not
enough to cause real problems to a stargazer in the middle. One
of the few times Frank became directly involved in civic affairs
was in an effort to stop the spread of light pollution. Around
1995, when Frank had opened the Mud Creek Observatory but

before he had achieved even a small amount of local fame, he heard that the city of Crandon, eight miles to the east, was considering a new street-lighting scheme.

Forest County Chamber of Commerce director Melinda Otto remembers it as the first time she met Frank and became aware of his nearby observatory in the woods. Although Crandon has a population of fewer than two thousand people, it is the county seat. In recent years it has become a hub of the seasonal tourist trade, but in the late nineties it was best known for an abortive copper mining project, thousands of acres of national forest land, and its role as the home of the Forest County Potawatomi Indian Community, which in 1991 opened what would become a thriving casino in Milwaukee, far to the south.

In the middle 1990s, Crandon's civic leaders decided that Main Street, a trading hub for the approximately 9,500 residents of Forest County and some residents of eastern Oneida County, needed a face-lift. They planned to install new sidewalks, blacktop, and gutters, along with redoing the sewer and water systems below grade. The city planners asked local businesses to participate in an adopt-a-light program, arranging sponsorships for decorative light fixtures on Main Street, instead of traditional, tall, overhead street lights on poles. The idea was to encourage civic engagement and brighten up the downtown while making it more attractive at night.

Frank Kovac saw the lighting plan as a possible intrusion upon his observatory's view of the night sky. The adopt-a-light plan forced him out of his mostly self-contained world of stargazing and odd jobs and into town, where he spoke to the committee organizing the program. Frank expressed concern that the swanky new fixtures would not be designed with stargazing in mind, that they would flood the sky with unneeded light instead of just illuminating the street and storefronts near them.

But Frank was not a Luddite intent on stopping change. Instead, he proposed a solution. "He asked them to consider thinking about light pollution and putting baffles on top [of light sources] so that didn't happen and people could still see

the stars," Otto recalls, adding that city leaders hadn't thought about light pollution. "People started thinking about how they do value seeing the night sky here as opposed to being in a big city." As a result of Frank's advocacy, Crandon is among the smallest communities that has installed baffles. Frank's interest in the dark skies movement and light pollution wasn't limited to Crandon. He became a member of the International Dark Sky Association and also appeared in Rhinelander, with less immediate but surprisingly lasting impact. "A former member of the Rhinelander City Council had come here for a showing," Frank recalls. "She told me that the council took my advice and they are slowly improving on better lighting fixtures as old energy-inefficient ones are replaced."

In his understated, determined way, Frank protected his vision and continued his quiet crusade. Even after he landed a steady day job at a Rhinelander paper mill, he continued to spread the word about the grandeur of the stars while building and tinkering with the observatory and its telescopes on his backwoods estate. Inviting visitors to the Mud Creek Observatory continued a tradition begun with high school friends back in Chicago.

That routine changed one summer evening in 1996 when clouds rolled in over Monico and no stars were visible from the observatory. This disappointed Frank and a group of Boy Scouts who had come especially to see the skies. "That was when I decided to build the planetarium," Frank recalls. He knew the task would be daunting, expensive, and unusual for a remote, rural area. But Frank was determined to build it, even if it took years.

Traditionally, planetariums are civic undertakings, sponsored by a school, university, museum, or broadly based nonprofit, such as Chicago's Adler. A planetarium is often a large, mosque-like structure, minus the minarets, with an arching domed ceiling onto which stars are projected by sophisticated and costly systems of lights and lenses. The planetarium nearest to Monico was in Wausau at the University of Wisconsin-Marathon County, more than an hour's drive away.

Frank knew that such a professionally equipped plane-
tarium was out of his reach financially. But the years of sub-
conscious thought burst through, helping him arrive at a differ-
ent solution—a large ball with the stars painted on the inside
ceiling. The ball would rotate at a forty-five-degree angle to
simulate the sky above Monico, but without the annoying and
unpredictable interference of clouds. Frank had painted stars on
the ceiling of his childhood bedroom, so why not just expand
the concept? Years later he was asked why he chose a rotating
globe. "It just came into my mind," was Frank's simple answer.

He did no research to see if anyone else had created a struc-
ture like the one he imagined; instead he relied on his native
intelligence, mechanical skills, and design sense to forge ahead
with the project. "It was almost like something was tugging at
me," he recalls. "I could see something, and I could envision
this before it even existed. I was telling people that I have an
idea of this thing and it doesn't even exist and not even on pa-
per yet. There were no blueprints and there was no money that
was planned for this. I always felt that I am going to make
something that is really unique."

So Frank set out to hand sketch his dream, and the draw-
ings look remarkably like what he ended up building. First,
Frank checked to see if he needed to consider any building or
zoning requirements. The Town of Monico said he did not need
anything as he was not on a lake, and officials in the Oneida
County Courthouse in Rhinelander referred him back to the
town. This pleasant catch-22 allowed Frank to forge ahead with
his plans unconstrained.

"It's almost to me a blessing that I didn't need a permit,"
Frank says. "The stuff I was doing was so beyond the building
construction codes that had I gone on with a permit and there
was an inspector checking, there would have been problems,
because this here was really out of the ordinary."

In Forest County, which has a legion of building codes
and local regulations, the situation would have been completely
different. That Frank bought land just a few miles west of the

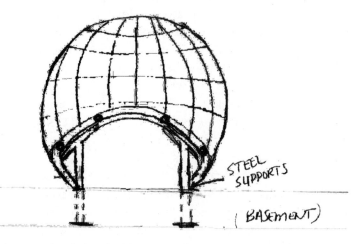

PLANETARIUM GLOBE
FRONT VIEW

STEEL
SUPPORTS

(BASEMENT)

Frank Kovac hand-sketched his vision for the planetarium globe. This image from 1997 shows steel supports and the basement he eventually dug.

invisible human-made border between Oneida and Forest Counties is an example of the hidden hand he believes guides his affairs. "Things came together," he says.

His plan set, Frank began working on his project, seeing it as a logical extension of the passion his father had awakened all those years ago in Lincoln Park with that small secondhand telescope. How proud he would be of his son and namesake when the completed planetarium was open for business, Frank thought.

And then, in 1997, less than a year into the project, and almost a decade before the first visitors would come to the completed planetarium, Frank Kovac Sr., muse of astronomy for his low-key but highly driven son, died of cancer at the age of sixty. In the North Woods of Wisconsin, Frank Jr. took it hard. For a

Frank Jr. and his father paused while taking a walk on logging roads across US Highway 8, near Frank Jr.'s home in Monico. Frank Jr.'s mother Mary took the photo. This 1995 visit to Monico was Frank Sr.'s last before he died in October 1997.

long time he pondered a fitting memorial. Finally, half a decade later, in 2002, he decided on a fitting remembrance: naming the completed project after his father. The Frank Kovac Sr. Planetarium would become a living memorial to the spirit of a man whom his son believes helped guide its construction, even after death.

7

SPINNING THE SKIES

Nothing can be created from nothing.
—Lucretius, *On the Nature of Things*

When Frank Kovac Jr. decided to build a rotating globe planetarium in the North Woods of Wisconsin, he was unaware that an effort was under way in his hometown of Chicago to revive a similar construction. The Atwood Sphere, a mechanical globe planetarium built decades earlier, was for many years the most advanced representation of the known universe in North America, but it had fallen into disrepair. Although Frank believed the mechanical globe planetarium to be his own invention, such devices have been around for centuries.

The Aermotor Company of Chicago built the Atwood Sphere in 1913 for $10,000—equal to more than a quarter of a million dollars today. That is more than Frank spent on his globe and the building that houses it. Aermotor's owner, La Verne Noyes, served on the board of the Chicago Academy of Sciences, which owned and exhibited the sphere. It was "made of 1/64th inch galvanized sheet-iron soldered to the equatorial ring and to a much smaller ring about the entrance to the sphere," according to a 1913 publication from the academy. Light shone through 692 holes in its skin, drilled at different sizes and in the proper positions to represent the stars over the Chicago neighborhood of Lincoln Park where Frank spent much of his childhood. Just as Frank envisioned for his globe about eighty years later, people

sat inside the Atwood while it spun around them to represent the movement of the heavens. The sphere weighed about five hundred pounds, was seventeen feet in diameter, and was tilted at 41 degrees, 50 minutes north, the same as the tilt of the Earth at the latitude of Chicago. Thus, the horizon in the sphere matched the horizon seen in Chicago, just as Frank's 45-degree tilt means the horizon in his sphere matches that seen in Monico. The sphere was named for Wallace W. Atwood, director of the academy at the time, who oversaw its construction. It was put on public display on June 5, 1913, and was an immediate sensation, as projector-based planetariums didn't exist yet.

Across the Atlantic, however, another rotating-globe planetarium had been around for more than two hundred years. Adam Olearius, a courtier of Fredrick III, duke of Holstein-Gottorf, built the sphere between 1654 and 1664 in what was then southern Denmark. The Gottorf Globe is approximately ten feet in diameter and weighs three and a half tons. In about 1700, the stars and constellations were painted on the inside. The globe was tilted at 54 degrees, 30 minutes, and a doorway was cut into it, allowing about ten people to crawl inside. It was illuminated by candlelight and moved by either waterpower or a crank (the historical record is unclear). Olearius, a mathematician by trade, had also been a diplomat for the duke, and at least one historian believes he had heard about a similar rotating glass sphere made for a Persian king in the third century, only to be destroyed in a later war with the Turks. In 1715 the Gottorf was presented to Russian tsar Peter the Great, who placed it in the Academy of Sciences Museum in St. Petersburg. A fire damaged it in 1741, but it was soon rebuilt. In 2002 the German government provided a grant for the restoration of the globe, and it now sits on display in the Peter the Great Museum in St. Petersburg. At about the same time the Russian globe was being restored, the Germans built a replica back in Gottorf, which is now part of northern Germany. It is displayed in a public garden there.

At least two other rotating globes were built in the seventeenth and eighteenth centuries, one in Germany and one in

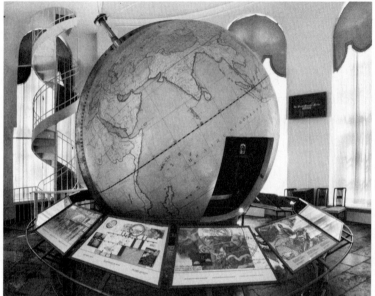

The rotating Gottorf Globe was built in Denmark in the seventeenth century and later moved to St. Petersburg, Russia, where it is now exhibited in the Peter the Great Museum of Anthropology and Ethnography.

England, but both have been lost. And through it all, as science and human understanding of the heavens advanced, so did the desire to make better indoor representations of the stars. In Germany, Oskar von Miller began to visualize a projection planetarium around the turn of the nineteenth century. However, it was only in 1924, after World War I, that the first one was installed at the Deutsches Museum in Munich. It used a projector developed by the Zeiss Optical Works in Jena, Germany. After this development, rotating-globe planetariums were pushed into the shadow of history.

The Atwood was especially ripe for eclipse when, in the 1920s, Max Adler, a Chicago philanthropist and an executive of Sears Roebuck & Company, decided his native city needed a projection planetarium. The result was the Adler Planetarium,

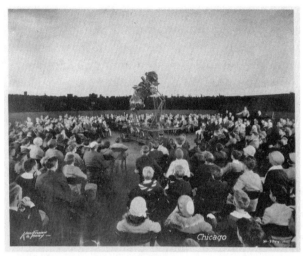

Chicago

Zeiss Archives

A Zeiss projector was the original equipment at the Adler Planetarium. This picture from the Zeiss archives shows such a projector being demonstrated for the public in the 1920s or 1930s.

which opened at the Chicago lakefront on May 12, 1930, equipped with a Zeiss Model II. It was the first such planetarium in the United States, and it greatly diminished the public's interest in the Atwood. Nevertheless, in archive files on the Atwood, a letter dated October 21, 1937, from Wallace F. Worthley, head of natural sciences at Francis W. Parker School in Chicago, protested plans for "junking" the sphere. "I have used the Sphere for my classes for many years, and have found it superior to the Planetarium in many respects," he wrote. The sphere survived and was even used during World War II to train navy pilots in celestial navigation.

But by January 1956, a decade before Frank was born, an article in the *Chicago Daily News* called the sphere "obsolete" and reported that academy officials were "open to suggestions for disposal." Soon thereafter, the Soviet Union launched *Sputnik*, the first artificial Earth satellite, touching off a frenzy in the

United States as Americans worried their nation was lagging behind in the sciences, particularly astronomy. A Chicago Academy of Science pamphlet dated February 1959 said the Atwood sphere "recently escaped razing as an eyesore. Academy officials decided that the white elephant could be turned into an asset in the 'Space Age.'" They did so by embossing the continents on the outside of the sphere, painting it, and hanging it in a hallway of the Academy of Sciences building. "When spotlighted, the result is a realistic representation of the planet Earth in Space," the pamphlet said.

This placement meant there was no way for visitors to get inside what was renamed the Globe-Planetarium. That was the Atwood manifestation that Frank saw in childhood, and it bore little resemblance to the rotating-globe planetarium he would later dream up. Eventually, museum officials renamed it the Atwood Celestial Sphere.

Meanwhile, the *Sputnik* scare and generous federal funding for education fueled a proliferation of planetariums in the United States, with installations in almost every state, many at colleges and even high schools. In addition to the dollars from Washington, development of a cheaper alternative to the Zeiss systems, designed and built in America, fostered planetarium growth in North America. After World War II, Philadelphian Armand N.

A headline from the *Milwaukee Sentinel,* October 5, 1957. The Soviet launch of the *Sputnik* satellite led to the "Space Race" and the creation of NASA.

Spitz created a planetarium projection system that relied on projecting pinholes of light on a dome rather than the sophisticated optics of the Zeiss system. Spitz projectors soon became the standard for US planetariums. By 1971, 743 planetariums were either running or under construction in the United States, with more than half in K–12 schools and about 30 percent at colleges or universities, 10 percent at museums, and the rest scattered in other kinds of institutions. "After *Sputnik*, people started building their own planetariums in their basements and garages," says Bob Bonadurer, director of Milwaukee's Daniel M. Soref Planetarium. "Small little devices, mostly shining light through holes." Spitz-equipped planetariums continue to dot the United States, but the digital revolution has made computerized projection the system of choice in recent years.

There was no planetarium at any of Frank's schools, and his only exposure to one as a child was at the Adler, where he saw its Zeiss presentations and took a few classes. In the Chicago of the 1970s and '80s, the Atwood Sphere was an aging relic without the cachet of Wrigley Field, which was about the same age.

In 1995, as the Chicago Academy of Sciences was preparing to move to a new building, administrators sent out an email saying they were considering getting rid of the Atwood. Later that year, the academy agreed to donate the sphere to the Adler. Adler officials then rehabilitated it, removing the painted continents. They re-drilled some of the star holes, built a new rotation system, and increased accessibility by means of a small cable-car-like device that moved visitors inside it. In 1999, as Frank was plugging away in the North Woods, the Adler reopened the Atwood to the public and now proudly calls it the oldest large-scale planetarium in the United States.

During both the original construction of the Atwood and its preparation for subsequent redisplay at the Adler, numerous technical problems arose. Adler officials discussed patenting some of the solutions they found to the original construction problems, but it is not clear if they actually pursued this. "In the

construction of the sphere many difficult engineering problems have been met and the exhibit as now installed demonstrates a rather remarkable solution of these problems," reported the *Bulletin of the Chicago Academy of Sciences* at the time the Atwood was first displayed. Almost a century later, Frank Kovac Jr. could make the same observation as he designed, built, and prepared his own rotating-globe planetarium.

ALL FALL DOWN

Courage and perseverance have a magical
talisman, before which difficulties disappear
and obstacles vanish into air.
—John Quincy Adams, *Oration at Plymouth*

Throughout the latter half of 1996, Frank spent most of his
spare time and many sleepless nights conceiving a design for
the rotating globe. He did the planning almost entirely inside
his head, although eventually he drafted a sheaf of pencil
sketches, beginning around January 1997, a few months before
he began actual construction.

The sketches crystallized his thinking, detailing how the
globe would be angled at 45 degrees, with an opening portal at
the bottom, and showing the gear that would rotate it. His al-
most meteoric flash of inspiration came after he remembered
the glowing-paint mural he'd created in his bedroom in Chi-
cago. He realized he could expand that youthful exercise by
painting the entire visible universe onto the inner surface of the
globe. Instead of reflecting light, as in a projector planetarium,
his stars would glow and radiate of their own accord, just like
their real counterparts.

"It just came to me," he said later, recalling the moment so
vividly that he switched from past to present tense. "I am think-
ing of doing it, believe or not, in a rotating globe where I can
show all the seasons. My vision is a big sky map where you can
get people inside it, which is a planetarium. But if it doesn't
turn, it is not any good."

A projector can move the stars it projects by shifting position; the projection surface needn't move at all. Frank didn't have that luxury. He would need to paint his stars into fixed places, just as the stars appear fixed in relation to one another in the night sky. He would have to design his tapestry to move in some other way to duplicate the celestial progression through the night as the Earth itself rotates. Given his financial constraints, he resolved to invent what was—as far as he knew—a new way of reproducing the night sky.

He realized it would be a daunting task. "Before the actual physical construction of the planetarium, I could visualize the structure," he recalls, "yet I knew something of this magnitude would be quite a challenge."

Although Frank remembers that much of the concept came to him in a single flash, history suggests the revelation had been building up inside him for years. Cosmologists pondering the birth of the universe generally have focused on the big bang theory of sudden universal creation, but that model says nothing about what preceded time and space. What earlier events enabled Frank Kovac's personal big bang of inspiration?

Pressed to think back, Frank remembers one such moment, when he was fifteen. Before glow-painting the planet Saturn and stars on his bedroom wall, he recalls excitedly telling his classmates he could replicate a planetarium with luminous paint. When the mural was finished a month or so later, Frank ran informal tours, proudly showing the resulting mural to his friends. Among them it became known as Frankie's Wall.

Marveling at his creation soon afterward, Frank wondered if he could not only paint the wall and ceiling, but create an entire dome. That question, put aside for years, gradually grew, unseen and relentlessly, like a super-gravity black hole, until it became too powerful for Frank to resist. *Bang!* Creation!

But how did that early bedroom project emerge? Frank identifies the main influence as the visually stimulating *Cosmos* television series. He also remembers discovering the original

ultraviolet, glow-in-the-dark paint and realizing he could use it for a mural. He found the paint at the American Science & Surplus Center, a regional chain store and a playground for the science minded. On the jammed shelves in its ever-changing aisles, do-it-yourself techno-nerds could scrounge for parts or kits to build scientific gear, including optics, gears, and motors.

The store and its wares further inspired Frank. Its shelves displayed some of the pieces the teenager needed to realize his dreams; he just needed a well-constructed vision. His love of tinkering first led him to his kit-based telescope as well as parts he obtained and refashioned. That project was an order or two in magnitude below his future planetarium, but it was of a similar nature and inspiration.

Along with his experience in high school shop class, all his youthful lessons and readings combined to stimulate Frank the Builder. His hands-on self-confidence grew to the point that one warm day, without prior approval, the teenaged Frank grabbed a sledgehammer and began ripping out the back wall of the family kitchen. His mother watched in amazed consternation as he pounded away. Frank Sr. came home from work in the middle of this unexpected demolition and confronted his son. "What are you doing to my house?" his dad demanded.

Frank recalls the way he explained it to his startled father: "I was already starting to get better doing stuff and knew I could be good. Imagine seven people in a family with this little kitchen. So I thought, we'll make it larger. And Dad had spoken about doing it, but I thought, I'll just start doing it—my own ambition." His practical father thought about Frank's explanation awhile, then said, "Okay, we'll get the drywall and put it together." And just like that, the remodeling project was approved and continued on to fruition.

The beginnings of the planetarium project, so many years later in 1996, may have been driven by Frank's fever dreams, but unlike earlier projects, this one took longer to lift off. He bided his time thinking through the complex undertaking.

Restless months of cogitation filled his free moments. "There were many nights when I was very tired," he recalls, "yet I could not fall asleep because I was thinking of the mechanical nature of such a structure. Sleepless nights were some of my problem-solving moments. Since there was no instruction manual, it was very much a trial-and-error project."

After months of reflection, Frank shifted out of theoretical mode into what for him was a far more comfortable process: the physical task of actualizing his dream. The clarity and fullness of his vision surprised him. Still, he regarded himself as very methodical, his impulsiveness regarding the family kitchen notwithstanding. "I am not one to come up with an idea and run with it until I have really thought it through," he says. "I found it very exciting to first visualize this and then attempt to make it a reality."

Unlike a vision, physical reality isn't particularly yielding. The construction project was riddled with false starts and unexpected troubles. In the trying decade of work to come, Frank would become a planner, a heroic journeyman, an adventurer with a clear mission. His undertaking required physical strength, resourcefulness, and, especially, a stubborn never-give-up attitude. And Frank seemed immune to crushing setbacks. His resolve was tested many times, but especially on two occasions when his globes crashed, the first one crumbling apart in March 1997.

He had fashioned that spherical dome out of thick polyvinyl chloride pipe, the white plastic stuff used in modern plumbing. The material seemed ideal: It fit together readily and would allow him to add panels upon which to paint his star field. It also had a kind of futuristic, airy look. And it was lightweight and thus more easily rotated. He bought eight hundred dollars' worth of PVC pipe and from August to October of 1996 sawed and glued sections of it into a slightly angular geodesic lattice. Then he halted work as winter set in.

The PVC globe looked like an igloo, sitting unprotected atop a wooden platform in the clearing he had created for it on

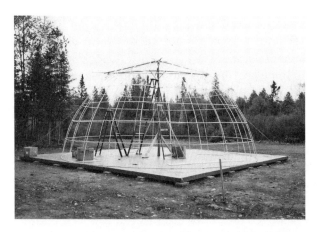

Frank used PVC pipe in his first attempt to build a globe.
In 1996 he had framed the skeleton.

his property. But one day in 1997, during winter's late fade, the
globe collapsed unseen. "It broke apart; it seriously failed," Frank
recalls.

He discovered the wreckage after coming home from his
mill job and looking out the window of his house. His first
thought was that he had wasted his money. The PVC pile of
failure now looked not like an igloo but like a deflated balloon
that would never fly again. He was crestfallen. "That was going
to be the planetarium, and I had all these pieces of pipe shaped
into this globe. But it was too brittle in the winter, and it fell
apart.

"I was so frustrated. I'm working out in cold weather, so . . .
I am just going to forget the whole thing, clean up the whole
thing, and just enjoy the telescopes. But something kept nag-
ging at me, like, 'Make it stronger.'"

A successful globe made of PVC would have cost less and
weighed only a third of what his eventual design weighed, sim-
plifying the entire project. Frank knew his next attempt would
be harder still. Yet he had learned something from this failure
and ultimately decided to push on. He would find a way to make

the globe stronger. It was the reboot of a quest that would ultimately require tens of thousands of hours of personal labor over the next decade.

Looking back, Frank is almost philosophical about his trials and tribulations: "I did indeed have many doubts and fears of failure, yet my passion for the stars and for sharing it with others pushed me to never quit."

He regards himself as a creative person and an inventor, finding potential solutions to his exotic problems in everyday situations and reapplying them. Sometimes he felt like some kind of mad scientist, toiling away on his own while skeptical strangers looked on from a distance. "It was as if nothing in the world would stop me. I felt like I was so driven that even in a few spare hours between my times at the mill, I would be here, working on this."

Frank's neighbors checked out his project and were quite aware of all the hours he was putting into it. More than once, they referred to the project not as "Frank's planetarium" but as "Frank's sanitarium." And Frank wondered, too, from time to time, what possessed him to continue: "Can you imagine spending years of your time putting this together and still not knowing if it's going to look like you're thinking?"

Indeed, later mishaps and unexpected challenges during construction gave Frank further cause to wonder if he would ever finish. He's awed that he did: "It is amazing to me how you can envision something and just make it happen."

Depending on how you look at it, Frank's achievement might seem not just amazing, but even mythic.

THE WEIGHT OF THE WORLD

I may be strong-minded, but no one can say I'm out of my sphere now.
—Louisa May Alcott, *Little Women*

After the collapse of the PVC globe and a brief mourning period, Frank went back to the drawing board—one that remained mostly a virtual drawing board consisting of images in his head. The late winter day in 1997 when he came up with a new plan was the first day of a renewed journey, one he later said he might not have followed had he known it would require another ten years of his life.

The seemingly Sisyphean project would take him into his early forties. One ally Frank had in his quest was his good physical condition. In the main sequence of adulthood, he was in trim physical shape. Physical toil too often puts premature wear on blue-collar workers. Into his thirties (and, as it turned out, a good number of years longer) Frank remained vigorous and youthful looking.

Working on his property, he often wore jeans and a hooded fleece sweatshirt, standard gear for many folks in northern Wisconsin, on or off the job. Sturdy ankle-high boots with good tread typically peeked out from under his denims.

A careful observer would sooner or later note Frank's fingers. Slender and long, they moved in an unusual, flexible, and angular fashion characteristic of hyperlaxity/hypermobility—medical talk for double-jointedness, a condition prevailing in

only a small percentage of the human population. The trait came in handy on many occasions when Frank used tools, especially heavier equipment that needed to be rotated into odd positions.

His personal work schedule often went like this: He'd truck home from his paper mill job in town, turning onto Mud Creek Road and twisting the steering wheel through the last couple hundred yards to the secluded, one-story house he had built for himself on his wooded property. He would greet his dog, Sweetie, grab a bite, and soon head back to work—only this time for himself, not the mill. He went on foot, hiking down an old narrow trail, over a small rise from his house to the clearing where he was turning his vision into reality. Building his globe was a painstakingly slow and even troublesome process, but he pushed himself along, remembering that his self-declared assignment was all about achieving something great.

He had two basic challenges: to find a new material for the globe, and to create a shelter for its construction. He tackled the shelter first. Working year-round outdoors in the highly variable climate of northern Wisconsin wasn't just hard on materials; it was challenging for a warm-blooded human. Eventually, the globe would need permanent housing, and the temperature would need to be controlled, not only to keep guests comfortable but also to keep the globe and its components from flexing too much as a result of temperature changes. Plus, rain and snow certainly couldn't do a globe much good. In the meantime, he needed something simpler, just a way to shield his construction site from the elements.

While still at work on the PVC globe, Frank had decided to build a pole-framed structure with tarpaulins covering the walls and a sheet-metal roof to protect against rain and snow. Frank already owned most of the needed wood- and metalworking tools. For raw material, his property offered many tall trees. He spent two months chopping down sturdy spruce and trimming the trunks into smooth, twenty-seven-foot-tall poles, tall enough to sink into the ground and still leave room for his

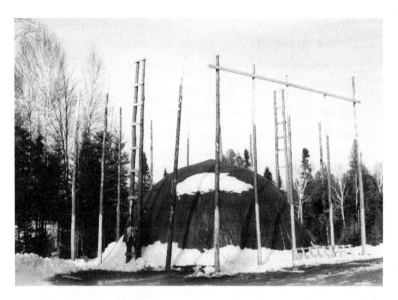

Frank Kovac began building a construction shelter while his PVC globe was still underway. When the PVC globe collapsed in March 1997, he focused on completing the shelter, then began building his wooden globe inside.

planned globe. With help from friends and family, he dug post-holes around the original wooden pad he had created for the PVC globe and arranged the poles into a large rectangle.

But before he could get further than that, the PVC globe had disintegrated under winter's assault, the very reason he'd begun the shelter. Once Frank decided to begin constructing a new globe, he cleared PVC debris and got back to work.

After erecting the frame of the shelter, he spent hours atop his tall ladder installing metal roof panels and draping over them three tarps, the very largest he could find at big-box retailers in Antigo and Rhinelander. The greyish tarps billowed in the breeze and gave the vague impression of a shroud concealing a secret undertaking. Neighbors would drop by to observe. "What are you building?" they would ask. "Is this some kind of government project?"

Among those who visited and on occasion assisted were his Uncle Mike and Aunt Christine, taking time off from their motel business in nearby Crandon. Once, Uncle Mike was so eager to show Frank how to perform a task near the top of the ladder that he climbed up there himself. Christine ordered the elderly Mike down for fear he would hurt himself. Mike never climbed the ladder again.

When spring 1997 began asserting itself, the enclosed shelter was ready. Frank eventually added guy wires and additional internal bracing to stabilize it. He figured it would last for the two or three years he might need it. As it turned out, the shelter would encase his creation for the next five years.

As for the second challenge, replacing the PVC as the skeleton of the globe, Frank began considering other materials. Looking around his forested property, the choice soon became obvious: wood. Wood was heavy but flexible and strong. It could be cut, fashioned, and glued or studded together. He didn't know how to bend the material, which he assumed he would need to do to create a spherical shape, but he would figure that out as he went along. Frank soon fixed on the idea of plywood sheets, a relatively strong, inexpensive product. He envisioned cutting curves out of the sheets and gluing layers together.

The basic design would remain the same: He would construct a latticed near-sphere, about twenty-two feet in diameter, with plywood sectioned and glued into thick bows. Then he would reinforce those intersecting pieces as necessary with metal plates. He would add panels to the curvilinear open spaces. On the interior of those panels he would paint his star field.

For electricity at the work site, Frank had to run a cable from his house through the woods, ending in a junction box on a nearby tree stump. From there, he distributed power throughout the shed, providing outlets for his tools and direct overhead lighting. He also set up an old woodstove in a corner, insufficient to make the shelter toasty but extending his workdays in cold weather. "And it kept the coffee kettle hot," Frank says. That was

a good thing, because his house was an eight-hundred-foot hike away, over a winding, hilly old logging road. A small electric space heater and a small propane one supplemented the stove and further warmed the particular area he was working in.

The only other amenity Frank allowed himself was a portable radio. "I spent many hours in that shelter, so it was nice to listen to music while working," he remembers. He recalls a Tuesday morning in 2001 when a local radio DJ announced that planes had hit the World Trade Center towers in New York City. "Of course we know the rest of the story. So, I will never forget where I was on September 11, 2001. The next day was my birthday. I felt very safe and secure tucked away in a tarp shelter in Wisconsin's North Woods."

On a typical afternoon, Frank would come home from the paper mill with a load of lumber or scrap wood he'd bought or scavenged. He would unload his truck and lay a plywood sheet in the shelter. Firing up his electric circular saw, he would cut along lines he had drawn with a makeshift compass, tracing out arcs on the sheet by swinging a two-by-four stick of lumber around a nail at the sheet's center.

Frank used this procedure to make many pieces of plywood shaped like arches. He used glue to laminate matching pieces together, thickening them. When he was done, a pile of wooden arches lay stacked on the floor like a gigantic puzzle he would have to fit together to make the sphere.

This craft work was mostly still coming straight from his mind, based not on any blueprint but on only a few freehand sketches and simple shop-math calculations. Neighbors and family members would drop in and gaze in wonderment as the three-dimensional sphere took shape. Where had Frank obtained the curved beams? Where were the plans he was working from? Even do-it-yourself carpenters usually have plans!

One of many unplanned tasks came along when Frank realized he would need to hoist the globe during its construction to work underneath it. However, his cramped temporary shelter was only twenty-five feet tall. That would not provide sufficient

clearance above the globe when he lifted it off the floor. He discovered as much when he tilted the globe while it was suspended, to see if it would fit atop an eventual, angled base ring and if it would bump the roof. Frank couldn't make the construction shelter taller, so he remedied the problem by removing the shelter's wooden floor and digging a hole in the ground.

Because the shelter was too small to bring in a backhoe or other excavating equipment, he dug out the entire hole with a hand shovel. It became a twenty-four-square-foot, three-foot-deep opening, and to create it he removed uncounted wheelbarrow loads of soil and rock between 1999 and 2000. He considered himself lucky not to have encountered a huge boulder or exposed bedrock. That would have seriously delayed or even killed the project, because breaking though such heavy material can be expensive, as Frank found out when it cost him $13,000 to sink a well on his property. With the extra clearance the new pit provided, he would now be able to raise the globe at its designed tilt without hitting the roof of the shelter. He had felt cursed by this newest problem—but it, too, would turn out to be providential.

A year went by; two years, three.

As the decade waned, Frank was ready to assemble the arches. This task proved tricky because he knew from experience with the late, lamented PVC globe that the structure would be flimsy without cross braces. Across months of hard work, Frank ribbed out the globe, cross bracing the intersecting wood ribs with bolted iron angles. He spaced the arched ribs equally in twenty-four sections, one for each hour of the day. He added the metal bracing because he knew the wood would flex and that the globe needed to remain fairly spherical to rotate properly.

He drew up a sketch of the thick base ring consisting of four sheets of three-quarter-inch plywood, cut narrowly and laminated together. The base ring would sit atop concrete supports at an angle under the globe's rim, touching it at the point where the globe's lower hemisphere was cut away for the portal. Projecting up from the base ring would be U-shaped metal brackets, each

containing a pair of ten-inch wheels made of tough rubber. The brackets would pivot slightly as a motor pushed on the globe's rim, which would then rotate atop the wheels.

From the day Frank began to make the arched wooden sections, it took four years to put the wooden globe together. He typically devoted eight hours a day to the task, week after week. The only time he stopped work on the globe was when the outdoor temperature fell below twenty degrees Fahrenheit, which in northern Wisconsin was months at a time. "Even a few spare hours between my hours at the mill, I would be here," Frank recalls.

Then, as his work on the globe neared completion, in March 2001 the second crash occurred, destroying the base ring. It caused less damage to the globe than the PVC crash four years earlier, yet the disaster posed greater challenges.

The danger the crash brought upon Frank was ominously foretold. Over the years, his neighbors had seen Frank's drive and desire, and they tried to make sense of the project and its purpose. Some of them weren't shy about suggesting that his

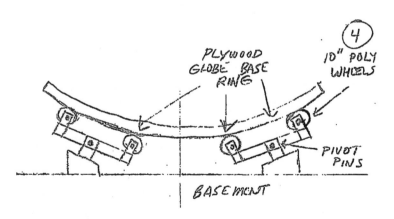

Frank Kovac sketched a design for a pivoting wheel system for the globe's base ring.

behavior bordered on insanity. Even some friends seemed skeptical. They knew he worked mostly by himself. One friend finally told him: "Frank, you're going to kill yourself out here." But Frank had confidence in his abilities, drawing on his experience in the air force.

To assemble, test, and position the globe, Frank had to put to use the skills he learned winching heavy nuclear weapons onto B-52 bombers. Frank had on numerous occasions used winches and heavy straps to raise the wooden globe off the floor and then back down whenever he needed to check the construction or make room to build the angled base ring.

On the evening of the crash, the temperature in the unheated construction shelter was only in the thirty-degree range, and it was getting dark outside. Frank worked right through the evening, by himself, as usual. It took him two hours to strap the massive wooden globe to four temporary cedar support poles at the construction shelter's corners, lift it off the floor, and reposition it so the globe's bottom rim could mate with the wheeled base ring.

The globe's heavy plywood creaked and groaned as it went up. Standing on a ladder in the globe's hollow center, Frank used his electric winch to lift the globe toward the roof of the construction shelter. He wrangled it so its opening shifted to a 45-degree angle as it came off the floor. Thus its bottom tipped upward, such that one edge of the opening was still near the floor. That was where the globe's rim would meet the base ring, resting on the ten-inch wheels set all the way around.

Suspended from poles on seven winch cables and ratcheted cargo straps, the globe looked a bit like a gigantic Tinkertoy. Frank regarded the object as the sum of all his efforts: 3,500 pounds of painstakingly assembled, handcrafted wood, which would weigh hundreds of pounds more when, as he planned, Frank added panels to the open framework. The sphere would then be completely enclosed, except for the circular portal that Frank had left open at the sphere's bottom, where visitors would enter.

Given that the globe's portal sliced its southern pole, the object could more accurately be described as a spherically shaped dome with an open bottom. Frank nevertheless referred to it as his globe. Neighbors kidded Frank about the UFO he was building. And in some ways the object did look a little bit like a shuttle from some alien mother ship. And now it was lifting off.

Winching the globe upward, Frank noticed the shelter sway a bit under the strain. But he judged that it would hold and proceeded with his test of the mating of globe and base ring. With a flush of excitement and anticipation, he let up tension on the winch and began giving slack to the four straps cradling the globe. As he expected, the heavy globe began to slowly rock back and forth as he guided its descent onto the base ring.

When the globe finally nestled in its new cradle, he released all but one of the seven winch and ratchet straps, letting the support ring take virtually all of the globe's weight. He climbed off his ladder and inspected the result. Everything looked good, so he tried pushing the globe back and forth, to see if it would rotate on the wheels. He stepped inside the globe and, using all his strength, rotated the massive globe a few inches as the wheels turned underneath. Success!

But then the globe, dangling from the remaining, uppermost strap, became unstable, rocking back and forth until it began sliding off the ring toward the floor. Underneath the globe, Frank ran to the center and crouched as it fell around him. Somehow, despite knocking away his ladder and sending thick splinters of wood in all directions, the globe not only missed Frank but came to an abrupt halt when the one remaining strap kept most of it off the floor. But he was temporarily trapped beneath the globe and the wreckage of the base ring, which the globe had sheared in two. Miraculously, the globe, like Frank, survived unscathed.

In the deep woods, Frank's nearest neighbors couldn't see his construction site unless they deliberately set out for his place, taking a final turn on the winding, bumpy road and driving down a small hill right into the clearing he had made. Fur-

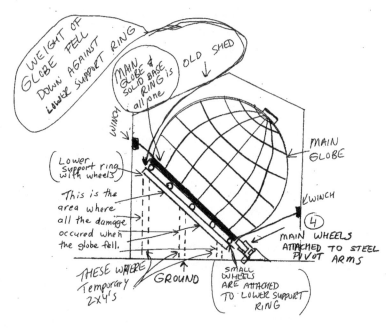

After the wooden globe fell in 2001, Frank Kovac documented what happened in this sketch.

ther up Mud Creek Road, out of sight but not out of earshot, Jerry's sixteen-year-old son, Tony, heard the loud bang of the crashing globe and ran down the road to the construction shed. "Are you okay in there?" asked Tony. Frank answered, "The darned globe just fell, but I'm okay—don't worry about me." He picked his way out through the globe's latticework and looked sadly at the mess of his project.

Jerry and Laurie invited Frank over for dinner that night. Their hospitality and company helped take the edge off. Still a bit shaken and having flashbacks of the PVC disaster, Frank wondered if he would ever succeed. But soon, he shifted gears. "It was my first attempt," Frank told his hosts, "and it did show that the globe might turn, but it doesn't look like it's going to work the way I planned. I need to support the globe somehow so it doesn't fall."

Frank thanked his neighbors for dinner and headed home on foot, knowing he needed a new plan. First, he would finish cleaning up debris from the ring. Second, he'd hoist the globe again, but this time keep it fully attached to all its support straps. Third, he'd repair the base ring. Fourth, he'd think up a better weight-bearing system, both for construction purposes and as a permanent solution. He just needed to do it in a new way. He would find that way—he had to, even if it took years.

After all, Frank thought, his spirits brightening again, this had been a test. The test had failed, but you always learn something in failure. Fortunately, the self-taught inventor had the patience and resilience of a Thomas Edison, for whom endless trial and error likewise was indispensable. Besides, Frank had faced danger; he had climbed tall trees, fallen those fifty stories in a defective elevator, and braved wild Chicago street traffic on his bicycle. He *had* survived, and he *would* survive.

That same night, he cleaned away most of the debris and used the same basic setup of winches and straps to lift the globe again, more carefully this time. "I could not see myself going to sleep that night until I was able to reset the globe at the 45-degree tilt again," he explained later. "I did not want the globe resting at that awkward angle, as it was putting a lot of stress on the wheel assemblies. From that day forward I never again released all the cables until the globe finally had steel supports under the base ring. Overall, I see the accident as part of the testing phase of the entire project."

In his revised scheme to lift the globe off the floor and keep it safely suspended on its track, Frank would take on the role of the Greek god Atlas, whose task it was to carry the celestial sphere upon his back. Unlike Atlas, the mortal Frank certainly could not carry his giant globe alone. He would have to find a better way to support its weight while keeping it stable. That was another challenge, and as he had done all along, Frank took it up with purposeful determination.

METTLE ON METAL

At one time I thought the most important
thing was talent. I think now that the
young man or the young woman must
possess or teach himself, train himself,
in infinite patience.
—William Faulkner

In the month following the wooden globe's fall, Frank rebuilt
the broken base ring. He became his own safety board, analyz-
ing how to better support the globe's weight, which would only
become greater once he added panels atop the lattices.

His first thought was to support the globe at its equator, but
it was not perfectly round, and that would mean finding a way
to compensate for uneven rotating speed and the same instabil-
ity that had brought the globe down. Eventually he hit upon an
overhead support. He remembered learning somewhere that
the strongest part of a sphere is its top. He experimented with a
temporary cable lashed to the roof of the construction shed,
with hopeful results. Based on that experiment, Frank promptly
sketched out and figured the tolerances for a spring and bearing
system to support a good portion of the globe's weight. It would
hang from the roof of the permanent building he hoped to erect
in the coming year.

He drew up a couple more sketches showing metal and con-
crete supports for the base ring. Together, the new collection of
sketches depicted a globe and orientation that looked remarkably
similar to the planetarium Frank would complete almost six
years later.

With the globe again hanging from its web of straps, Frank worked fearlessly below to measure the temporary two-by-four wooden supports so he could replace them with steel. This new construction phase brought additional metal-working demands, but for all his skills, Frank did not weld. Fortunately, Frank's neighbor Jerry was a skilled welder and eagerly volunteered.

Jerry had already put in considerable time, helping acquire and assemble metal joints. He had done much of the welding, while Frank used Jerry's drill press to punch holes in metal plates and fittings. The two men did all the metalwork in Jerry's garage, which featured a well-equipped workshop, including a welding unit and power tools. Other work colleagues and friends—about a dozen in all—put in time during the years of effort, but Jerry was far and away the most frequent volunteer. He even assembled the original metal components of the base ring that they now needed to rebuild.

Even though Frank estimates that he himself put in 90 percent of the project's sweat equity, he depended on Jerry a great deal. "I needed him a lot; the guy is very intelligent, and me and him together, we started thinking about the way this thing should be supported." Jerry's presence was, in Frank's reckoning, "another thing that was providence here—a guy that lives near me who is very good at welding and very good at mechanical stuff. He was able to help me when I needed the help. It fell into place."

Jerry, meanwhile, lists three things that inspired him to help Frank over the years: "Number one, Frank is family to us; he's our neighbor, he's our family." Also, Jerry enjoyed shop projects and liked figuring things out. And third: "I could not leave him to himself," Jerry says. "I didn't want to see him dig a hole. I wanted to see him succeed."

Frank had the vision, the imagination, and the drive, according to Jerry, but not the complete set of trade skills necessary to accomplish a project of such magnitude alone. Frank also tended to dive into a project without a completely realized plan. And sometimes, as Jerry notes, "Just jumping in is not a good thing."

The way Jerry saw it, Frank would sometimes head down the wrong road to a dubious solution, as in the case of the PVC globe. So as the work proceeded, Jerry would suggest approaches or point out issues that needed to be resolved. Frank listened, and adjusted. The two men complemented each other.

In Jerry's view, Frank was more laid-back and less driven while working on the PVC globe. It was a beautiful if impractical inspiration that Frank ran with because it wouldn't cost that much. He had taken, according to Jerry, a "let's see what happens" approach. Without a trace of irony, he says the failed PVC globe turned out to be a "pipe dream."

Jerry was involved more at the beginning than at the end of the wooden globe construction. Putting together the metal supports, the two men, in his words, "pretty much trashed my shop saw cutting all that stuff." Jerry never charged Frank a penny. Frank bought or scavenged all the materials and reimbursed Jerry for his own material costs, including replacement welding rods. The two men also took apart Jerry's shop saw and together managed to get it going again.

Throughout their work, Frank would often come over to Jerry's house and help with family chores before the two men would head to the garage. They spent hours over many months working on angled metal bracings. The project required hundreds of these. For a while, Frank was buying out an Antigo steel parts dealer every couple of weeks, until the firm restocked.

One special metalworking challenge was a relatively complex, circular brace for the north pole of the wooden globe. Frank originally had considered using wood for this, but he decided it was not strong enough. He looked around for another solution and found a piece of stainless steel in the mill's scrap pile. Stainless is harder to weld than ordinary steel, and the part required Jerry to weld twenty-four connecting points, one for each wooden rib joining near the pole. "Had the piece been regular steel it would have also worked just fine. I just used what was available to me at the time," Frank recalls.

Although he was not a welder, Frank was capable of cut-

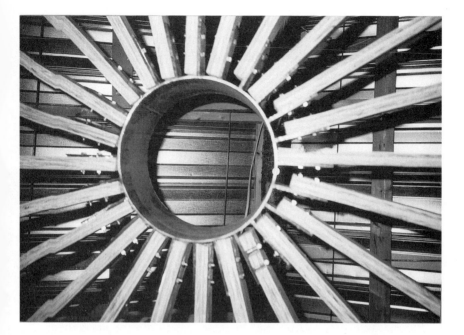

To anchor the twenty-four sections of the globe, Frank Kovac and his helpers fabricated a stainless steel ring, shown here.

ting metal, using an old Craftsman-brand saw his dad had given him. Just as he was finishing the very last cut on the circular brace, the saw burned out. Frank thought of this as another sign that some higher force was watching over him, perhaps even his father's spirit.

The two men would sometimes work until nearly midnight. Frank realized he was calling on Jerry to help a lot during wooden globe construction and worried about what Laurie might think of all this. According to Jerry, his wife was quite supportive and patient, checking in on them in the garage and sometimes dropping by with hot chocolate.

Frank makes it clear his method was mostly educated guesswork, along with a little arithmetic. "I had to decide how are people going to get in there, and I measured for where is the floor going to be. I was using some two-by-fours to kind of see if

this would be right. I have to say, trial and error, trial and error. If this wasn't right, then take a piece of cardboard and cut it out before you start scraping lumber. That is what a lot of this was. I know shop math good, but don't give me algebra and trig."

Once the base ring was rebuilt, it was time to pour a concrete floor. Frank had built a concrete perimeter wall when the temporary shelter went up in 1997, but the floor was plywood. Frank removed the floor portion beneath the base ring's wheel assemblies to pour a concrete pier around solid steel pipes that replaced the timbers that temporarily supported the base ring. He poured the basement concrete floor in the summer of 2001.

Two contractors poured the main concrete floor pad and a supporting wall in April 2002. Meanwhile, after five years of globe construction, it was time to pull down the temporary pole shelter, which had been needed longer than Frank had expected. He covered the wooden globe with giant tarps until a permanent metal building could be constructed.

Frank approached the challenge of finding a permanent home for his globe in his usual methodical manner, aided by the Internet. He considered putting up a building from scratch but quickly rejected that possibility. "I decided that it would be more economical to buy a prefab building," he says. He also thought a prefabricated structure would help him better meet requirements for a structure open to the public.

He considered a geodesic dome, an architectural form much favored by the counterculture of the '60s and '70s, famed for its simplicity and economy. There would also be a pleasing architectural wholeness to placing a dome over his globe—both structures are spherical and based on a web of braces surrounding flat surfaces of different sizes. Furthermore, domes, or dome kits, were commercially available; properly built and decorated, a dome would be a striking presence in Wisconsin's North Woods. But quick calculations showed that a geodesic dome with enough floor space and height for Frank's needs would be quite large and expensive. So he dropped that idea.

Next, he considered a pole building, a relatively cheap, highly

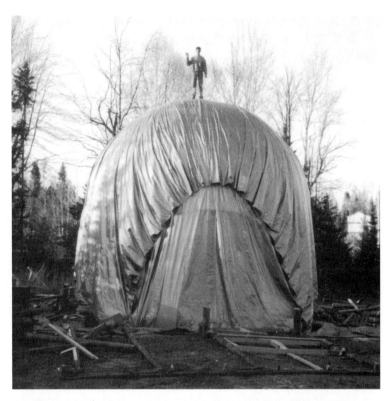

One day in April 2002, Frank Kovac placed a tall ladder behind the tarped globe and climbed on top to pose for a "king of the world" snapshot. This was in the period between the old, temporary wooden construction shelter and the metal truss building that became the planetarium's permanent home.

efficient, post-and-beam construction extremely common on North Woods farms, where aesthetics are less important than value. Several contractors in the Rhinelander area were adept at building this kind of structure, but Frank decided that, artistically, they were not to his liking. And he had a practical objection, too. "Pole buildings are more like a big garage," he explains, "and I also had to consider that I needed to span the existing planetarium, without any center building supports."

So Frank went looking for another solution and came upon

prefab metal buildings, the kind made famous by the Quonset hut of World War II. With the Quonset's curved metal roof, the problem of a center beam went away, and Quonsets were available in enough sizes to meet his needs. But he crossed that off the list, too, feeling they looked too much like barns.

Finally, thanks to an online search for "truss buildings," he came upon prefab structures created by Miracle Truss. They looked less like a barn, had sturdy steel support beams, and appeared easy to construct, almost like an Erector Set toy. In fact, the firm had grown from a company that had originally made Quonset hut-type structures but came to realize that some potential clients, such as Frank, needed buildings with more flexibility. Thus was born the Miracle Truss design, which uses a steel framing system that can be assembled in more boxy shapes than the Quonset.

Frank called the Minneapolis-based company's customer sales line. The building kits themselves were manufactured in Watertown, South Dakota, about 460 miles from Monico. They are most commonly used on farms, for airplane hangars, or as railroad repair shops, according to Justin Dekker, former chief operating officer of the company and the son of its immigrant founder. Frank ordered one about 25 feet high with approximately 2,200 square feet of floor space, seemingly perfect for enclosing his globe planetarium and providing extra space for exhibits, a ticket/souvenir counter, and restrooms. As far as Dekker knows, it is the only Miracle Truss building used as a planetarium.

Miracle Truss did not offer financing, which raised the question of how to pay for the building. And then came another of the godsends that had helped the project. Mary Janeczek, Frank's father's sister, died in Chicago at age seventy-six in January 2002. That spring, Frank received $18,000 from her estate, enough to pay for his Miracle Truss kit.

The kit arrived by flatbed truck in May 2002. A local tree service provided a boom to unload it, and neighbors came to help bolt it together. On June 22, it was erected with the help of

a rented crane. Then, Frank spent a couple of weeks putting up a metal roof and sidings, using a rented scissors lift. Neither Oneida County nor the Town of Monico required a permit for any of this work.

With a permanent building now enclosing the globe, Frank took off the tarps that had protected it during the Miracle Truss installation. He installed a spring on a special beam in the roof and connected it to the globe's north pole. Now he was prepared once again to lower the globe onto the angled base track, hoping to avoid a third crash. Frank turned on the winch and held his breath. "I lowered it onto the supports, and after the slings were released, oh, my goodness. Finally, this thing sat there."

He went searching for a motor that would turn the globe with appropriate efficiency and power. Jerry did some serious research, figuring out the ratios required to turn the globe at an appropriate speed with sufficient power and proper torque. They settled on a half-horsepower Dayton-brand DC electric gear motor. It seemed ideal. The motor came with a rheostat control for variable adjustments, so Frank could turn the globe slower or faster depending on his needs.

Whatever weight the overhead spring and bearing did not support rested against a wheel on the outer side of the globe's bottom rim. The motor turned the wheel, and the whole thing would, if all went as planned, revolve atop the base ring's own set of wheels—"like a merry-go-round," Frank explains.

Jerry drill pressed holes and added sprockets he'd found at a Fleet Farm store in Antigo. When the assembly was complete, Jerry told Frank, "Hit the switch—you made this." That was December 3, 2002, a day Frank says he'll never forget. "I hit the switch and the motor sure enough turned on, but the globe wasn't going anywhere." The drive wheel spun uselessly, an anticlimax for the two men who had worked so hard to figure out a way to make the motor turn the globe. But this initial disappointment gave way to thought, and they figured out the problem: Frank had brush-coated the leading edge of the globe's rim with a polyurethane finish. "I made it really shiny," he says. "I wanted

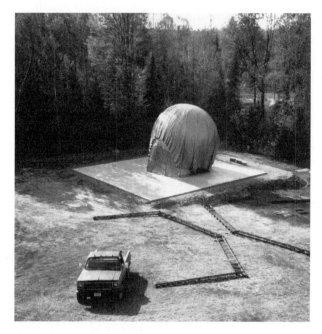

When the Miracle Truss building kit arrived, Frank Kovac began to assemble its girders.

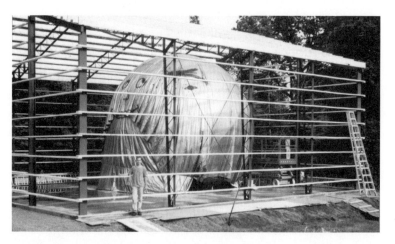

The skeleton of the Miracle Truss building surrounded the globe, which was protected by a tarp embellished with a smiley face.

it to be preserved." But the finish provided too little friction. Frank grabbed some sandpaper and roughed up the finish. That solved the problem, and the drive wheel turned the globe.

But it was like tuning a bicycle, where tightening one spoke makes you adjust everything else around the rim. Next Frank had to adjust the tension on the globe's top spring, which was still a little off. That solved another problem but led to the wheels making loud noises. He had salvaged his first set of rubber wheels from the paper mill where he worked, but he discovered they were too soft to make proper contact with the rim. He thought of polyurethane, only this time in the form of very dense wheels, which wouldn't deform or squeak under the globe's weight. He found a set, and they seemed right, but it all took more time and cost Frank another $500.

Next he discovered that in a single rotation, the globe would wobble one inch to the side because it was not perfectly round. He would have to compensate for that by allowing the support mechanisms to give a little. Pivots that self-adjusted as the globe came circling around, along with the right amount of tension on the overhead spring, solved the problem. And so on, and so on.

But then a new phase of the project started. In the early months of 2003, Frank decided he would run the planetarium as a business, charging admission. That meant the state took an interest. "I called the Commerce Department in Madison," Frank recalled. "They said, 'What is it?' and I said, 'I made it.'" Who built it was of little interest to the bureaucrats; they had standards to apply. Finally, permits would be needed. The state had to make sure the business was safe for the public, no matter how obscure its location or unusual its product. Frank needed the imprimatur of a state-certified engineer. He also had to meet electrical and plumbing codes, and provide access for people with disabilities.

Frank hired a consulting engineer from the area, who inspected what was done and prepared the needed documents. And he brought in certified electricians and plumbers and modified the floor plan to provide state-required wheelchair access.

Providence again intervened: The basement he had been forced to dig while still working in the temporary shelter unexpectedly gave him just enough room in the permanent building to put in the required wheelchair-accessible ramp to the floor beneath the globe.

At the time, Frank was working steadily at the paper mill, bringing home a good income, half of which went to paying the suppliers for his project. In all, he spent about $21,000 on the state-required improvements, more than the building itself cost. He also continued to spend almost all of his spare time on the project, finally getting the last paper notarized and mailed down to Madison in 2005. Although he never met a state inspector face-to-face, relying instead on certifications from the professionals he hired, Frank calls the time "stressful," a great change from the creatively satisfying free hand he'd had in building the globe and erecting the Miracle Truss.

But even then, he was not ready to open to the public. "There was a lot of inside detail work yet to be completed," Frank recalls. That included installing carpets, hanging wallpaper, and, most importantly, painting the stars on the inside ceiling of the dome.

THE MICHELANGELO
OF THE NORTH WOODS

Some painters transform the sun into a yellow spot; others transform a yellow spot into the sun.
—Pablo Picasso

At the end of 2002, Frank Kovac was well on the way to reaching his goal. Building the two-ton planetarium, and getting that plywood and metal sphere to rotate, was a herculean effort requiring almost all of his intelligence, imagination, and mechanical genius. Turning the globe into his ultimate vision would require digging even deeper into his emotional, financial, and creative reserves, but Frank was undaunted.

The new challenge was easily defined, if vast in scope—painting stars on the inside of the sphere to simulate the sky above Monico—in other words, painting the visible universe. The challenge paralleled that faced by Michelangelo in the sixteenth century when he agreed to paint the walls and ceiling of the Sistine Chapel in Rome. The result became an icon of high Western culture—frescos of the stories of creation, the Garden of Eden, Noah's flood, prophecies of the coming of Jesus, and scenes from his life.

Frank's aspirations were more modest. The painting would resolve his strong inner compulsion to share the wonder of the heavens as well as construct a fitting tribute to the father with

whom he had shared that wonder. Unlike Michelangelo, Frank did not have to paint human figures to fulfill his vision, nor did it take him more than four years, as it did Michelangelo. Also, Frank worked alone, while the Renaissance Italian had many helpers. But the challenges of painting the ceiling of the Sistine Chapel and the inside of the Kovac Planetarium were eerily similar.

Start with finding the proper paint and how to apply it. Michelangelo had to learn the proper way to apply paint to plaster so as to harm neither while making sure the result would last. He had done some work with frescos in his youth, but after becoming a mature artist he had preferred sculpture. As he went to work on the chapel ceiling, mold that infested paint and plaster became his worst enemy, but eventually he mastered an appropriate fresco technique.

Similarly, painting was not Frank Kovac's favored form of expression; he was foremost an inventor and a mechanic. As a child, he was fascinated by the Adler Planetarium and the Museum of Science and Industry in Chicago much more than by the Art Institute farther uptown. But when painting became necessary to fulfill a larger vision, he embraced it as a challenge. Frank had experimented with painting as a youth when he created his version of a spaceship approaching Saturn on the wall of his childhood bedroom. Just as important, he had found a way of painting stars on his ceiling.

When Frank set out to paint his bedroom wall, he went to the American Science & Surplus store and bought green glow-in-the-dark paint. But he quickly realized he needed something different in Monico. The initial glow of such paint was bright, but it dimmed quickly. That would not do. Neither would black-light paint. "You are going to get a cool image, but it is not going to look like you are out at night," he says. So he broadened his search and discovered many other glowing paints that might fill his need.

Frank called the Rexton Company in New Jersey, the leader in glowing paints at the time, and was told the firm's blue-glow

paint would work best for his project. The paint cost $200 a quart, so Frank ordered one ounce and did a test on his Monico bedroom ceiling. "After painting a few stars, I was not impressed, but was very disappointed," he says. "I did not notice it to glow any better than the green stuff" of his youth. However, when he awoke, he was surprised to see very distinct star points glowing very brightly. "My first thought was, that is the right stuff to make the planetarium image possible," he says. "Apparently, when I first applied the quality glow paint, it was not dry yet, which did not allow the glowing effect to be very evident." Once dry, the Rexton paint glowed for eighteen hours. So far, so good, but then there was the question of how to maximize what visitors would see. Here, the Rexton bottle provided the answer: its directions said the paint worked best on a white background, which in the dark would appear black and make the painted stars jump out.

But just as Michelangelo had to figure out how to apply paint to plaster, Frank needed to determine the best way to create a white surface for his paint. He had decided to cover the roughly triangular spaces between the interior wooden ribs of the globe with one-inch-thick polystyrene foam rather than another layer of much heavier wood. Now he had to make the pinkish styrene white. His first, conventional attempt, painting a white base coat, failed, the paint flaking off. Thinking hard, he devised another method: roughing up the panels with a wire brush and then applying three coats of paint. That worked. When the styrene panels dried, he installed them—all 312 pieces, some as small as a pie slice, weighing 250 pounds in all.

His next challenge was getting into the proper position to paint, another problem he shared with Michelangelo. The Italian artist invented a scaffold system that allowed him to work on the walls and ceilings almost sixty feet above the ground while still letting church rites be performed below. For Frank, the challenge was a bit simpler because he could rotate his surface, whereas Michelangelo could not. Although the planetarium sphere was twenty-two feet in diameter, he needed to get up

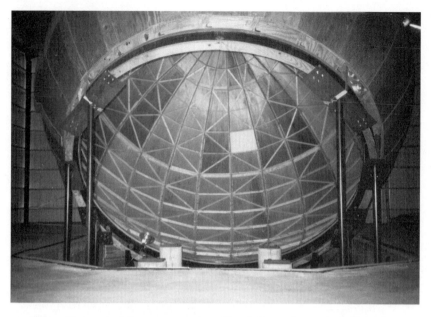

When the outer globe was complete, Frank Kovac began installing the first of several hundred white-painted styrene panels that became the background for his star field.

only seventeen feet, the level of the North Star inside the tilted sphere. The sky revolves around the North Star, which does not move when the planetarium rotates, so it became a fixed point of reference for Frank's painting. He had to be able to paint from the North Star all the way down to the horizon—that is, not all the way to the bottom of the globe, but only to where the real horizon would be, which also happens to be the level of the shelf that holds the globe's back display lights. When he was done with one portion, Frank could rotate the globe so the next portion was even with the North Star. He built a scaffold from two-by-four lumber and plywood. And to reach the highest points, including the North Star at the top of the polar axis, he put a ladder on the scaffold.

Like Michelangelo, Frank painted standing up, as working on his back would allow paint to fall into his eyes. But unlike

the Italian master, he was almost always alone when working. He says this was sometimes scary, especially when he stood on a ladder on the scaffold. Frank never fell.

Even after he mastered the techniques, Frank faced the question of where to paint the stars and how brightly. Here, too, Frank shared challenges with Michelangelo. The Italian knew that painting on curved surfaces far above a viewer meant he had to distort his figures so they would look realistic to observers many feet below. Frank had a similar challenge. He also painted on a curved surface and needed to make the stars appear in their proper relationship to observers below. This he accomplished through trial and error, but even as late as 2014 he was not completely satisfied with the results.

Michelangelo was constrained only by the need to accurately depict the story he was telling. But Frank sought to render his universe to re-create the night sky outside the planetarium on a clear night. To accomplish this, he used a star map, observation, and his own memory. "I used a quite notable star map book as a guide," he recalls, referring to his thumbed copy of the *Norton Star Atlas*. "I took it apart and used the individual pages up on the ladder/scaffold to help me position the stars." He sometimes used a ruler and little faint pencil dots to mark proper locations. He painted the ceiling in sections delineated by the panels he had installed and the wooden cross braces. Each panel contained up to fifty stars. "Recall that I designed the planetarium according to the same pattern as star maps show," he says.

Frank always let one portion of the painted ceiling dry before moving on. He would go outdoors and look at the stars in question to make sure they were the proper brightness compared to the others in the sky. The method succeeded only because he has good image retention. "I'd say that star is way brighter than it should be, the North Star doesn't look that bright. Dim it out with (ordinary) white paint. That was the eraser," he recalls.

Frank faced another challenge. He had only one color of paint, and the paint was only so bright. But stars differ in color and brightness. How would he paint a red star like Acturus? Red

and other colored glow paints did not work. They dimmed too quickly. So Frank had to make compromises. To make a star like Arcturus appear bright enough, he decided to paint it slightly larger in his sky than it is in nature. The result was a good enough approximation.

The Milky Way posed a special challenge. It appears not as individual stars, but almost as a faint smudge across the sky. Frank decided to paint it last and needed to invent a special technique to make it appear real. His first idea was to put some glow paint into a spray bottle and aim it at the proper places. That didn't work. The paint did not apply evenly, requiring him to repaint some stars it had obliterated. So he erased the spray painting with white paint and used a sponge soaked in his special paint to capture the smeary river of the Milky Way. That did the trick.

His rendering of the Milky Way is "fabulous," says Jean Creighton, a doctor of astrophysics and director of the Manfred Olson Planetarium at the University of Wisconsin-Milwaukee. In a visit to the Kovac, she noted the difference in brightness of stars from what she is used to in Milwaukee and discussed with Frank the technical challenges of addressing that. Despite the limitations of his paint, "Stellar brightnesses are pretty accurate," says Aaron Steffen, a professor at the University of Wisconsin-Marathon County in Wausau and director of its small planetarium. Both experts say Frank positioned the stars with great precision.

Having decided the ever-changing moon was too much of a challenge to depict, Frank left it out. But he faced one more test after painting the stars: the planets. Unlike stars, planets move noticeably over the course of a year, changing position in the sky relative to the other celestial bodies. Indeed, the word *planet* comes from a Greek root meaning wanderer. So to include planets, Frank would either have to constantly repaint them or find another solution. "I had originally used those small slide furniture leg stickers," he recalls. "I found out they did not stick well to the rough surface." So instead, he uses 1.5-inch glowing safety

dots. "I now attach them to the panels with small nail tacks, and adjust them accordingly."

In all, it took Frank from January to May 2003 to correctly paint the approximately five thousand individual stars, and the Milky Way as well. But that does not mean it is 100 percent accurate or complete. There are many more stars out there, but Frank wants to limit his star field to what is visible to the human eye under ideal conditions right outside the building. "I had to do just what we see. No planetarium should show anything more, other than a slide or video to help enhance the show," he explains.

And what can be seen in Monico is quite spectacular for anyone accustomed to stargazing in an urban area. Reviewing his display, Creighton was fascinated to notice several clusters not usually visible in Milwaukee, in particular the Lagoon nebula. As Frank spun his globe for her and the Lagoon appeared, she asked, "You can see that with the naked eye here?" "Up here at night, yes," he said. "You can see the clouds of it. And people say it used to be better, because now when I look at it you are looking south toward Antigo, and Antigo's lights are encroaching in that direction."

And Frank is not done. "In my spare time, I add or subtract paint to stars that I feel are still not exact," he says. "To the average person this sounds foolish, yet I see it as a work in progress."

That Frank got things so close to right is a good thing, of course, but in a larger sense, it is more important that he *tried* for accuracy while creating a masterpiece of human creativity. "It is neat to think that this is the only planetarium on the planet where one gets this visual experience," says Frank. And he keeps it all in perspective. He notes that the term *planetarium* is centuries old and comes from little mechanical machines intended to show the other planets, sometimes in motion. In the twenty-first century, we have a better understanding of the universe. As Frank says, "We could call them star-tariums, now."

A SOUL PROPRiETORSHiP

Make no mistake, my friend, it takes more than money to make men rich.
—A. P. Gouthey

Many have been drawn to Wisconsin's North Woods hoping to harness its resources and make a fortune. Native Americans scratched a living from the region's abundant water, wood, and wildlife. Early European immigrant farmers burned forests and prospered for a time on the nitrogen-rich ashes that destruction left. While that played out, nineteenth-century timber from the region built and rebuilt Chicago. Developers in the rest of the nation bought North Woods products by the shipload, turning the region into the nation's wood basket. All this extraction created hugely wealthy barons who were able to buy vast political and economic influence in the Gilded Age. In the twentieth century the North Woods attracted another generation of fortune hunters who exploited forests and produced paper at mills, such as the one that employed Frank Kovac when he came to the area near the end of the millennium.

Producing this wealth required not just technical vision and creativity, but also business skill and a ruthlessness common to many captains of industry. Frank Kovac Jr. also brought vision and creativity to the North Woods, but his soul has not a particle of such ruthlessness.

He came to lose himself in the stars, not in a bank account. Money to him is a means to fulfilling an end, not the end in

itself. He did not incorporate but rather ran his business as an individual, *soul* proprietorship, one reflective of his deepest desires and yearnings, not a textbook exercise in maximizing profit.

As a result, the Kovac Planetarium is a throwback, harking to an era before every enterprise became a commodity managed by fresh-faced young MBAs homogenizing information for computer analysis. And that is part of the Kovac's charm. Frank has a laptop to help with his show, but not much more automation. His nearby house lacks an Internet connection, and the planetarium itself is on DSL. His cash till is computerized, and he has begun to accept credit cards, although he is still happy to accept checks, or the promise of one, for his modest admission price. In 2014 he was charging $12 for adults, $10 for seniors, and $8 for children, with discounts for churches, schools, camps, scout troops, and other groups. He sells soda from a small refrigerator stocked by trips to a discount store and offers a few souvenirs such as T-shirts and hats with the planetarium logo.

The Kovac Planetarium has no employees except Frank, and his only debt is on his house, although he took a second mortgage on it to help complete the planetarium. His lifelong vision was paid for with earnings from his job and a couple of small inheritances. In all, it cost him about $180,000 for land, materials, and equipment.

Cash flow for the planetarium is highly seasonal, with the vast majority of its patrons coming in the summer months. Yet the operation is open year-round, and even if it were not, Frank would still need money to heat and secure the building. He has worked without a line of credit to help smooth out these seasonal mismatches; instead saving during the good months so he has money to spend during the lean. He has business and liability insurance, which he pays for monthly. As a union member working at the Rhinelander mill he had health insurance, but as the sole proprietor of the Kovac Planetarium, his coverage became a challenge. Eventually he obtained coverage through a

program for veterans. He gave up full-time outside employment in 2012. In slower months he occasionally finds pickup work such as an evening janitorial job or, ironically, painting at a concrete company in Rhinelander. During slower months he has worked as many as twenty-nine hours per week, but he hopes he will never again need to work a full-time day job.

Frank understands the value of publicity for his planetarium, but he has worked without an advertising or public relations agent. He believes most of the planetarium's visitors find out about it from previous patrons, with the rest finding him through publicity or advertising. Ninety percent are from Wisconsin, and most of them from the North Woods, where the regional population is widely spread out and would fit into several square blocks of Manhattan or Frank's native Chicago. He belongs to the local chambers of commerce and provides brochures to put in displays at their headquarters and hotel information racks. It took a nudge from his insurance agent and sometimes business mentor to get Frank to write to the dozens of summer camps in the area, suggesting a trip to the planetarium as a good rainy-day activity.

The Kovac hosts between 3,000 and 4,500 visitors annually. This includes several hundred from substance abuse centers and groups serving the mentally and physically challenged, whom Frank makes a particular effort to attract and inform.

When the word does get out and people come to the planetarium, Frank is extremely open to journalists and other curiosity seekers and always generous with his time. A reporter for the TV station in Rhinelander came out to do a story but only after getting a tip about it from one of Frank's neighbors. Before that, she had not heard of the extraordinary project being constructed just down the road from her studio. A handful of articles have appeared in regional newspapers. *CBS Evening News* twice showed a segment on the planetarium, most recently in August 2013. That was thanks to a producer with roots in the area. National Public Radio's *Story Corps* project featured an interview with Frank.

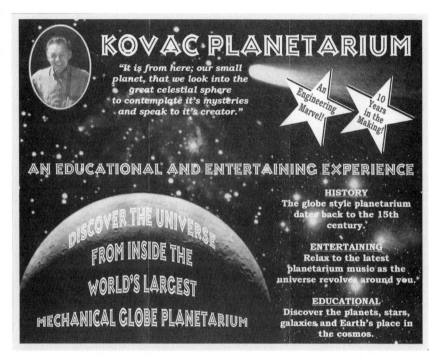

Frank Kovac created this planetarium brochure, which is distributed in the Rhinelander and Crandon areas.

In the beginning, the only road sign for the enterprise was a small white board with black letters that sat almost in one of US Highway 8's ditches and said simply "Planetarium." Eventually, that sign ran afoul of the highway authorities, and Frank had to take it down. So in 2012 he paid about a thousand dollars to have the state install regulation tourist signs in both the eastbound and westbound lanes of the highway at driver's-eye height. Better signage has increased business significantly, although Frank notes it was one of his larger marketing expenses.

He can use the traffic, because Frank needs material as well as spiritual nourishment. He keeps expenses low, cleaning the planetarium's bathrooms himself and not even thinking of hiring help. He has no attorney. He pays property and income taxes, as if the planetarium were a store.

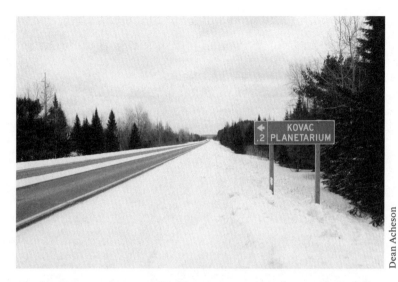

Dean Acheson

Frank Kovac went to considerable expense to pay the state to install a pair of signs on US Highway 8 directing people to his planetarium.

Some people have suggested to Frank that turning the planetarium into a nonprofit organization would be financially beneficial, as it would allow him to avoid such expenses and accept gifts from supporters. Even his loving mother has pointed out the contrast between the organized support for the Adler Planetarium and Frank's simple operation in the North Woods. The Adler is a multimillion-dollar nonprofit, with systematized fundraising, donor recognition, and tons of support from local politicians and businesses. But Frank is not interested in changing his operation or scaling up. "If he is a charity there is a lot more paperwork to deal with and the cost of setting it up," said Wayne Link, Frank's longtime accountant in Crandon. "The other part of it is he would probably have a board [of directors] and I think he is happy where he is at just running it by himself." Says Frank simply: "I don't understand all that."

Following the initial CBS coverage in 2010, Frank says he was approached about franchising his idea or possibly setting up a touring exhibition. He rejected all such advances, believ-

ing they would complicate his life and dilute his focus on the North Woods. His website was hacked after the program, adding to his reticence.

He has the same attitude toward his considerable technical inventiveness. Several of the methods he developed to build and rotate his globe have unique elements and could be patented, providing him with legal protection and a potential source of income. But Frank is not interested. "I heard some guy tell me patents are headaches," he says. "If somebody wants to do it they can go for it. My globe, it is a one of a kind. I just wanted to enjoy it."

Rather than using his creativity to buy the world, he prefers to use it to understand and observe the universe. And feed his soul.

TO THE PAINTED UNIVERSE AND BEYOND

Open afresh your round of starry folds.
—John Keats, "I Stood Tiptoe"

In June 2007, five years after the Miracle Truss kit arrived and more than a decade after he decided to build his globe, Frank received a letter from the Wisconsin Department of Revenue with his seller's permit and tax withholding number. He had put in about ten thousand hours of work on the planetarium and at last was ready to open and could legally charge admission. All that was missing was a well-earned grand opening celebration. But Frank lacked the roughly $3,000 he figured he needed to pay for the party. So he waited until July 2008, even though some visitors showed up before then.

Frank remembers the opening day fondly. He hired a DJ and a tent, and provided catered food from a local restaurant. About 120 people attended; they drank beer and soda, ate broasted chicken, and vied for door prizes, including a $100 gas gift card. At one point, Frank's Uncle Mike from Crandon grabbed the microphone. Frank recalls he said, "Listen, everybody! Frank did a lot of hard work here. There was blood on this job here. I came over here and I see Frank digging. I say, 'Frank, what the hell are you doing here?'" The crowd erupted in applause.

Then Frank spoke, paying homage to his father in a speech he had carefully composed. He read, in part:

You have heard that we should never judge a book by its cover or a person from their outward appearance, because it's what inside that matters. Well, inside that crude structure surrounding the globe while it was being built was history in the making. Many cold, wet, muddy, snowy days were spent not on a warm couch in front of a TV, but out here year after year striving for what seemed like an unattainable goal: the stars above.

A mountain climber has his sights on the summit. My sights were on the stars above, and through many years of perseverance, I have reached my goal and it is indeed a dream come true. Many years ago in a moment in time, a dad took the time to show his child the stars. In that child a spark went off which set forth a burning flame, a flame that has been burning ever since. The light of that flame has been my guide through many difficult days.

May the flame that my father passes on to me burn with the same intensity as the stars above, so that all those who visit the Kovac Planetarium may also reach for the stars and be guided by their light.

The Frank Kovac Senior Planetarium is officially dedicated in memory of my late father. It is from here on our small planet that we look into the great celestial sphere to contemplate its mysteries and speak to its creator.

Frank's neighbor Jerry, who had done a large portion of the welding, took the day off from work and attended the big event along with his family. They joined Frank's former coworkers, who had also helped with the welding. Jerry was proud to have helped, and to attend the opening. "You could see it in his face," he says of Frank's speech. "It was what he was born to do. Not everyone can make a living doing their dream."

Like a dream, the Kovac Planetarium evolves and changes, growing deeper and better. At the start, Frank's presentations were very straightforward: here is Polaris, here are the constellations, this is how the sky moves during the night. To project other images, at first he used a tilted Kodak Carousel slide pro-

jector. Eventually, he dumped the slides in favor of a laptop computer and a tabletop projector, greatly increasing the number and type of images available for his shows. Yet no matter what technology he uses, Frank's shows always inspire awe.

Nowadays, he will sometimes include a video showing how quickly the Earth appears to become nothing but a dot and then vanish altogether as one hurtles through space. Sometimes, he will include the history of the planetarium. And he always chats with customers before the show, gauging their knowledge and interest in the stars and other matters; then he customizes his presentations to pique those interests and fill their knowledge gaps.

Three or four times, Mary Kovac has made the long drive from Chicago to see her son's planetarium and his show. Once she noticed a woman looking down at the floor, seemingly tired or depressed. "But by the time she left it was like she was a different person, smiling and acting as if it had changed her whole life," Mary recalls.

Dean Acheson

Frank Kovac begins a planetarium show for a small group. The globe seats up to twenty-five.

Frank's hands-on approach is part of a long tradition. According to the job description for the first Adler planetarium director, the director would be "a person learned in astronomy, able properly to operate the planetarium instrument in said Planetarium, and qualified to explain to visitors the celestial display and operation of said instrument." The self-taught Frank Kovac Jr. certainly fits that description for a job that paid at least $7,500 in 1928—or more than $100,000 today. But the next clause would trip him up: It specified that the authorities "will not at any time employ as Director any person not having the qualifications required by law and deemed necessary by the Department of Astronomy of the University of Chicago."

The Kovac Planetarium stands outside the mainstream of institutionally supported planetariums run by college-educated professionals across the world. Compared to the present-day Adler on the Chicago lakefront, with 470,000 visitors a year and an annual budget of $16 million, the Kovac is a piece of folk art. As does Frank, the Adler produces some of its own programs. But unlike Frank, the Adler also collaborates with other institutions for co-productions and buys licenses for prepackaged presentations. Big Bird appears on posters advertising shows under its main dome in the Grainger Theater. The Adler has two other theaters and last used a Zeiss projector in 2010. Since then, the Grainger has featured an ultra-high-resolution digital display system that combines twenty projectors into a seamless image. And 36,000 square feet of exhibit space surrounds the theaters, filled with about eight thousand objects from antiquity to beyond man's landing on the moon.

The Adler is in the top strata of planetariums anywhere on the globe, but hundreds of others occupy a middle ground. Many are at educational institutions, including the Manfred Olson Planetarium, tucked inside of the physics building on the campus of the University of Wisconsin–Milwaukee, about 220 miles south of the Kovac. Director Jean Creighton manages it with a charming mixture of educational vigor and entertaining pizzazz. The Olson is equipped with a Spitz A3P projector,

common in planetariums built in the 1970s and '80s, and visitors sit around it in a series of circles in a traditional planetarium style. The Olson has added four digital projectors in recent years. The arrangement allows Creighton to present standard fare, such as showing the constellations and movement of the stars; but she also integrates more modern graphics, such as star pictures captured by the Hubble Space Telescope, which Frank shows at the Kovac, too, thanks to his laptop.

When Frank gave Creighton a tour of his North Woods operation in the hard winter of January 2014, it was clear they shared a similar passion for the stars. They also talked about the details of running a planetarium, exchanging tips on how to hide unwanted light from a projector and talking about the most difficult constellations to show to audiences. They agreed that Cancer is one such constellation because of its dimly shining stars. They compared notes on prices and admission policies, and talked about their competition, the Adler in particular.

Creighton was especially intrigued by Frank's method of simulating meteors with a handheld flashlight. She also appreciated the contraption he'd fashioned out of an old turntable, lasers, a saltshaker, and a water bottle to present a light show for younger audience members.

Frank sees the reaction of such professional astronomers as Creighton as a validation of his work. Even though his facility is a low-tech planetarium—at least by twenty-first-century standards—he perceived that Creighton was impressed with his facility.

Despite the technical and academic gulfs between them, Frank finds common purpose with professionals: "To reach out for discoveries and likewise share those discoveries with the general public is very gratifying." That, he adds, is the goal of all planetariums. And while technical precision is important, so is enthusiasm and a presentation style that imparts a sense of wonder. If the presenter isn't enjoying the moment, audiences are less likely to engage.

"The reason I love this job is because I get to do shows and I get to mix with the public," Creighton told Frank.

"You do shows in a way that you are comfortable with," Frank said.

Creighton agreed. "If I didn't," she said, "what's the point of it?

AFTER THE UNiVERSE, WHAT?

Still climbing after knowledge infinite, and always moving as the restless Spheres.
—Christopher Marlowe, Tamburlaine the Great

Frank Kovac Jr. is an American original. The son of a World War II refugee father and a Kansas farm girl mother, he grew up in working-class Chicago as the postwar economy expanded and national self-confidence grew. Frank was surrounded by loving parents and siblings, supportive friends, and understanding teachers who encouraged his scientific passions. He was fortunate enough to live in a city with one of the world's greatest planetariums and astronomy museums so he could fuel his youthful passion in ways not available to most Americans—or people almost anywhere else.

When Frank realized he could not thrive in the traditional academic mold, he found a different way to fulfill his potential and create a sense of peace and purpose. "I went through a different door," Frank says. "It doesn't mean you have to have college to do something." The result is a unique achievement: the Kovac Planetarium.

Frank Kovac is not unduly modest about his accomplishment, nor is he a braggart. He is generous in sharing his creation with the community and has always taken great pride in passing on his knowledge of the skies. Had he been marooned on a deserted island, he probably would have used every bit of his creative energy and available material to build something

similarly inspiring, if less grand. The Kovac Planetarium is an end unto itself, a profound expression of human striving.

In earlier times, Frank's detailed, observational knowledge of the heavens would have marked him as a man apart. In some primitive societies, he might have emerged as a mystic, the institutions he built becoming places of reverence and pilgrimage. In later times, across the Western world, as religious establishments came to dominate and in many ways limit creative human thinking, Frank's astronomical teachings and observations could have invited trouble.

If he had been able to mold his mind in a more academic manner, modern-day Frank might have achieved his youthful dream of soaring among the stars in the astronaut corps, rather than watching the stars from Earth. But in any time or circumstance, Frank Anthony Kovac Jr. would have remained true to himself and his innermost vision.

Raised in a Catholic household, Frank still practices the faith and retains a deeply spiritual personality. Of the universe, Frank says: "I believe the Creator made it happen over a long period of time. I have had people in here that are atheists. I never put them down; they never put me down. When the lights go out it doesn't matter what I think. We are all struck by the vastness of that universe."

His presentations are filled with awe-inspiring narrative, but the facts of the universe are allowed to stand on their own. As presenter, he may have his opinions about what it all means and why we are here, but what he communicates to his visitors is the vastness and astonishing beauty of the universe. His creation reminds visitors that the point of life is to do good work, be true to one's inner desires, and respectfully share the results.

Yet for all his inner strength and outward calm, living in a world of intellectual and physical equilibrium is impossible for Frank Kovac. The planetarium is up and running, but it is continually changing. Along with other regular maintenance duties, he still climbs his tall extension ladder to the top of the globe from time to time to inspect its surface and to check the

spring support mechanism that keeps the globe stable. He's not up there often. When he is, he is alone. But even in between those inspection climbs, he remains on top of the world.

He is always on the lookout for new slides to include in his show, and better ways to project them, given his limited budget. Even without new slides or equipment, no two shows are the same. Compared with the scripted presentations at places like the Adler in Chicago, shows at the Kovac Planetarium are free-form jazz.

And Frank Kovac continues to improve his property, even as, in the second decade of the twenty-first century, he approaches fifty. He has started to feel the effects of aging. His back is weaker and his eyes aren't as sharp as they once were. He thinks that with those weakening peepers it would be harder to paint the universe now, so he's glad he started when he did. Even so, he is building a new observatory between the planetarium and his house, something more permanent than the shed he modified in his childhood backyard, or the jury-rigged structure that served as the first Mud Creek Observatory.

As for what will become of the Kovac Planetarium when he is no longer able to run and improve it, Frank has no idea, but he hopes it lives on. "Hopefully it would continue to operate at a similar and possibly an expanded capacity. As for now, I myself plan to continue sharing my interest in the universe with visitors. Also, if finances improve, I plan to add to the existing facility more museum-quality displays. I want to improve; I don't want to stay stagnant," he explains.

He recalls a teacher who came to a show with her students and told them, "Listen, class: perseverance. Frank persevered, and that's why this is here." Frank then told the children, "If you have a dream, regardless of what you want to do in life, go for it."

Others have made note of Frank's tenacity. The Military Families Learning Network, a US Defense Department blog, has an entry on him, writing that he "has demonstrated that in terms of knowledge empowerment, people no longer have to

wait on someone else—a teacher or a mentor, for example. . . . Call it the Frank Kovac effect."

The Frank Kovac effect is on full display in Wisconsin's North Woods, as the world's largest rotating-globe planetarium spins away, inspiring awe in thousands. But its creator remains at his core what he was all those years ago when he painted the wall of his basement bedroom and dreamed of going to Saturn: a little boy fascinated by the stars and trying to be close to them.

Now, when Frank visits his mother in Chicago, he continues to take pleasure in the space mural on his basement bedroom wall, the 1980s project he credits with starting it all. In 2008, he even touched up the mural with blue glow paint; now it shines all night, just like the planetarium. Brother Matthew is the one enjoying the mural every night, however, as he now occupies Frank's former bedroom. When Frank stays in Chicago, he sleeps upstairs, a little bit closer to the stars.

The mural of Saturn that Frank Kovac painted when he was a teenager is still in his childhood home.

ACKNOWLEDGMENTS

This book came about with some of the same serendipity and word-of-mouth awareness that epitomize the Kovac Planetarium itself—and it took nearly as long to gestate. In fall 2008, Ron Legro had a casual chat with his family's housekeeper, Sandy Kaeselau, a Milwaukee resident who had just returned from a vacation at a summer resort cottage five miles west of Crandon, Wisconsin. Sandy described how, one day during that stay, she and her husband, Ken, had spotted a small white sign that had newly popped up along US Highway 8 a few miles west of their summer place. It was Frank Kovac's first sign advertising the turnoff to Mud Creek Road and his planetarium. The Kaeselaus had always enjoyed sitting on the front porch of their cottage and gazing at the rich star field of the northern Wisconsin sky. They promptly made a reservation to see a Kovac Planetarium presentation. A couple of days later they were treated to a showing that Sandy says felt "very intimate . . . very personal." That was partly because of Frank's easygoing, soft delivery and also because the entire audience that particular afternoon consisted of the Kaeselaus and one other couple. Sandy recommended the experience to Ron. Later that fall, on an unrelated business trip through the region, he carved out time to visit Monico and take in the Kovac.

Ron, too, was impressed, not just with the place, but also with the man. Like Sandy, Ron shared his experience with other friends, among them Avi Lank—friend, neighbor, fellow writer, and former colleague at the old *Milwaukee Sentinel.* Avi eventually made his own northern trek to Monico with his wife. They took in the show and were similarly impressed. Avi was sure the planetarium and how Frank had willed it into being would make a great book. In the meantime, additional patrons and other journalists noticed the Kovac Planetarium, and Frank's project became the subject of regional newspaper and TV news features. In 2013, Ron offered the Kovac project to Avi, but neither man felt he had time to take on the project alone; thus our agreeable coauthorship.

But even two authors do not alone make a book. First and foremost, this story could not have been written without the enthusiastic cooperation of Frank A. Kovac Jr. himself. Unfailingly polite, thoughtful, and helpful, Frank sat for countless hours of in-person interviews, provided reams of archival material, and answered scores of email queries. Just as forthcoming and gracious were his mother, Mary; brothers Matthew and John; sister, Kathleen; and Kathleen's husband, Rob Meyer. Frank's uncle, Mike Kovach, and his wife, Christine, also were generous with their time.

The staff of the Adler Planetarium in Chicago was instrumental in fleshing out the early Kovac story and the history of planetarium globes, in particular Jodi Lacy of the Webster Institute for the History of Astronomy. Also helping, via email, was Frank Zarp, heading up public relations for the Stiftung Schleswig-Holsteinische Landesmuseen Schloss Gottorf in Germany and the staff of the Peter the Great Museum of Anthropology and Ethnography (Kunstkamera), Russian Academy of Sciences, St. Petersburg.

Assisting in our research were the staffs of the Whitefish Bay (Wisconsin) Public Library, the Golda Meir Library at the University of Wisconsin-Milwaukee, and the Luther Library at Midland University in Fremont, Nebraska. Technical and

historical insights came from professional astronomers Jean Creighton, director of the Manfred Olson Planetarium at the University of Wisconsin-Milwaukee; Randy Olson at the University of Wisconsin-Stevens Point, and Aaron Steffen of the University of Wisconsin-Marathon County. Bob Bonadurer, director of the Daniel M. Soref Planetarium in Milwaukee, helped kick off our own, figurative quest for the stars.

In northern Wisconsin, we relied on the knowledge and expertise of Oneida County Register of Deeds Kyle J. Franson and his staff; Melinda Otto, executive director of the Forest County Chamber of Commerce; Lara Reed, executive director of the Rhinelander Chamber of Commerce; Wayne Link, CPA, Crandon; David Schuppler of David Schuppler and Associates Insurance, Rhinelander; Pat Medvecz; astrophysicist Margaret Turnbull; Perry Grueber at Wausau Paper Co.; and Michael E. Schnautz, Town of Monico assessor.

To find out more about the Miracle Truss Co., we were helped by John Broeker, Justin Dekker, Tom Dougherty, Steve M. Mihalchick, and Sam Orbovich.

Robert Vick of the K. I. Sawyer Heritage Air Museum in Marquette, Michigan, helped with information about the base at which Frank Kovac served.

Also volunteering their individual talents were Jan Nevitt, Norbert Nubler, Dan Patrinos, and Maureen Schroeder. Walter Davison, MD, was also an inspiration. Bernice Legro provided a way station and logistics in Antigo for some of our expeditions to Monico. Dennis McCann and Michele Derus read a draft of the text and provided helpful comments, but any errors are those of the authors.

"A camel is a horse designed by a committee." So goes an old saw we were well aware of when deciding to coauthor a book. As a result, we took great care to avoid humps in the manuscript we submitted to the Wisconsin Historical Society Press. The Press then surprised us by assigning not one, but two editors to our work, raising again the specter of our draft horse being transformed into an ungainly camel. How wrong we were.

Editors Andrew White and Catherine Capellaro provided not only informed suggestions, but entertaining commentary as we four worked together to make our work a sleek thoroughbred. Along with Kathy Borkowski and Kate Thompson, the Press provided a team any author—or pair of authors—would be proud to have.

Finally, we could not have accomplished this mission without our wives, Michele Derus and Dannette Lank, who offered their moral support, endless patience and cups of coffee, and timely suggestions. Not long before this book was complete, the four of us attended a show at the Manfred Olson Planetarium at the University of Wisconsin-Milwaukee campus not far from our homes. We walked through freezing night air to sit with a warm circle of others, sharing the wonders of space and time.

A NOTE ON SOURCES

All quotes from individuals, as well as information about the biography and career of Frank A. Kovac Jr. were obtained during interviews by the authors. The interviews were conducted in person, by telephone, and via email. Many descriptions, including the look of the planetarium and the environs of northern Wisconsin, are derived from direct observation by the authors. All population data is from the 2010 US Census. Wisconsin geographical information came from the *Wisconsin Atlas & Gazetteer*, tenth edition, DeLorme, Yarmouth, Maine, 2008. Following are sources for other information.

Chapter 1

For details about Carl Sagan we consulted a copy of his book, *Cosmos*, using the Ballantine Books edition of November 1985.

Chapter 4

Excerpts from the songs of Lou and Peter Berryman come from www .louandpeter.com/allyhlyr.pdf.

Information on nineteenth-century immigration was summarized from a Wisconsin Historical Society article at www.wisconsin history.org/turningpoints/tp-018/?action=more_essay.

The history of logging in the state is told more fully at www .wisconsinhistory.org/turningpoints/tp-027/?action=more_essay.

An article from *Wisconsin Natural Resources* magazine describes the state's original "virgin" or "old growth" forests: http://dnr.wi.gov/ wnrmag/html/supps/2004/octo4/intro.htm.

A Wisconsin Department of Natural Resources paper provides further detail: http://dnr.wi.gov/topic/ForestPlanning/documents/Chapter04.pdf.

The list of seven human-made wonders of Wisconsin is available at www.travelwisconsin.com/article/things-to-do/seven-of-wisconsins-man-made-wonders.

An extensive list and description of unusual Wisconsin roadside attractions can be found at www.wisconsinosity.com/links/links_web.htm.

The "graveyard" of giant fiberglass sculptures in Sparta, Wisconsin, can be examined at www.slate.com/blogs/atlas_obscura/2013/12/27/fast_fiberglass_mold_graveyard_in_sparta_wisconsin.html.

The University of Wisconsin-Madison study on urban versus rural perspectives is viewable at www.polisci.wisc.edu/Uploads/Documents/wisc/walsh_geography_of_power.pdf.

Chapter 5

The quote from *Winter Holiday* by Arthur Ransome can be found on page 31 of the 1934 American edition, published by the J. B. Lippincott Co., Philadelphia and London.

Information on the Kovac property purchases and other land dealings are contained in the files of the Oneida County Register of Deeds. See in particular volume 552, page 663; volume 615, page 705; volume 627, page 13; volume 649, pages 839–840; volume 698, page 794; volume 767, page 75; and the Mud Creek Assessor's Plat of July 9, 1996.

Information about average cloud cover in the Monico, Wisconsin, area is from http://weatherspark.com/averages/31463/Rhinelander-Wisconsin-United-States.

Chapter 7

Basic information about the history of planetariums was gathered from *Planetarium: Window to the Universe* by Charles F. Hagar and Carl Zeiss, Oberkochen, West Germany, 1980, and *Theaters of Time and Space: American Planetaria, 1930-1970* by Jordan D. Marché II, Rutgers University Press, New Brunswick, NJ, 2005.

The history of the Atwood Sphere comes from a fact sheet dated June 5, 2013, published by the Adler Planetarium, as well as from information in the files housed in the Webster Institute for the History of

Astronomy at the Adler in Chicago in the following places: series 11, exhibits 1912-2006, folders 1 through 22, and series 12, boxes 1 and 2.

The quoted description of the Atwood is from *Bulletin of the Chicago Academy of Sciences,* volume 4, no. 2, May 1913, as are the observations on the technical problems in building it.

The letter from Worthley and the *Chicago Daily News* article are in series 11, box 1, folder 1 at the Webster.

The article saying the Atwood "recently escaped razing as an eyesore" is in the Chicago Academy of Sciences publication *Museum Activities,* no. 9, of February 12, 1959.

Information on the Gottorf Globe came from Hagar, the Webster files, and the following websites: www.schloss-gottorf.de/barock garten-und-globushaus/globus and www.kunstkamera.ru/en/museum _exhibitions/5floor/globe/.

The story of Olearius perhaps hearing of a similar glass globe made for a Persian king is contained in *From Heaven on Earth, the Long Road from Giant Globes to Projection Planetaria,* an English typewritten translation of an article by G. W .E. Beekman in *Sterne und Weltraum,* June 1985, no. 6, pages 310-314. It was translated by Susan Nance Carhart and is in series 11, box 2, folder 14 at the Webster.

Data on the number and spread of planetariums in the United States by 1971 comes from Marché, pages 179-180.

A copy of the email from the Chicago Academy of Sciences on the future of the Atwood is in series 11, box 1, folder 5 at the Webster, titled "Atwood Sphere—Acquisitions and Logistics Notes, 1995."

Valuing 1913 dollars in the twenty-first century was done using www.bls.gov/data/inflation_calculator.htm.

Chapter 11

Information on the life and career of Michelangelo was gathered from http://arthistory.about.com/od/famous_paintings/a/sischap_ceiling .htm, www.livescience.com/40802-sistine-chapel.html, and http:// entertainment.howstuffworks.com/arts/artwork/sistine-chapel -michelangelo-paintings.htm.

Chapter 12

The *CBS Evening News* segment can be found at www.cbsnews.com/ news/wisconsin-man-builds-planetarium-in-backyard/.

The StoryCorps story on the Kovac Planetarium can be found at http://storycorps.org/listen/frank-kovac/.

Chapter 13

The job description for the original director of the Adler Planetarium is found in an agreement in series 11, box 2, folder 13 at the Webster.

The salary in twenty-first century dollars was calculated using www.bls.gov/data/inflation_calculator.htm.

Epilogue

The Military Families Learning Network blog can be found at http:// blogs.extension.org/militaryfamilies/2012/09/06/the-frank-kovac -effect-and-what-it-means-for-your-future/.

ABOUT THE AUTHORS

Dan Patrinos

Ron Legro

Dannette Lank

Avi Lank

Ron Legro and Avi Lank are journalists based in Milwaukee. Ron is a native of Antigo, Wisconsin, and Avi grew up in Rochester, New York.